IMAGES
of America

SUMMERS
COUNTY

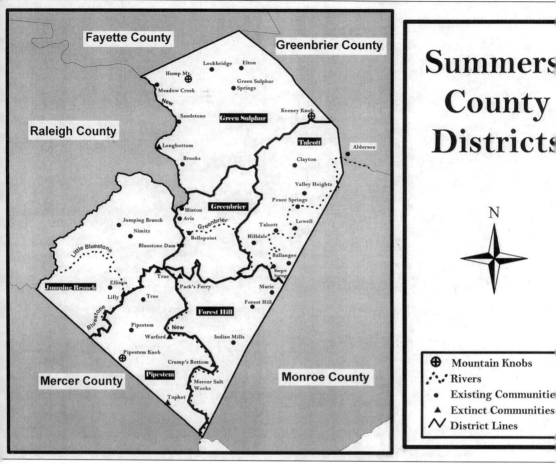

This map of Summers County shows the six magisterial districts that were used during most of the county's existence as well as in this pictorial book. In recent years, the magisterial districts have been reduced to three—New River, Greenbrier River, and Bluestone River Districts. Administrators still use the historic six districts for taxing purposes. The map also shows some of the county's physical features and villages. Hinton, the county seat, had a population of 2,880 in 2000. The next largest community is Talcott with a population of about 400. Note that the community of "True" is listed twice. The extinct village was on the Bluestone River. Its post office was moved to Tallery Mountain due to the construction of Bluestone Dam. (Map courtesy of Jaime Wykle.)

IMAGES
of America

SUMMERS COUNTY

Ed Robinson

ARCADIA

Published by Arcadia Publishing
an imprint of Tempus Publishing Inc.
Charleston SC, Chicago, Portsmouth NH, San Francisco

Printed in Great Britain

Library of Congress Catalog Card Number: 2003106978

For all general information contact Arcadia Publishing at:
Telephone 843-853-2070
Fax 843-853-0044
E-mail sales@arcadiapublishing.com
For customer service and orders:
Toll-Free 1-888-313-2665

Visit us on the internet at http://www.arcadiapublishing.com

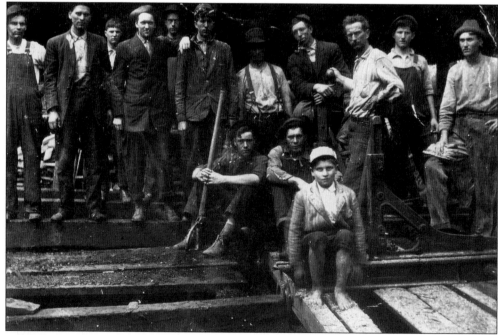

A hundred years ago logging was a major economic activity in Summers County. This c. 1910 photograph shows the Henry Meador sawmill crew near Pipestem during one of their "breaks." Notice the railroad tracks that were used to transport the lumber to the market. (Photograph courtesy of Pipestem State Park.)

CONTENTS

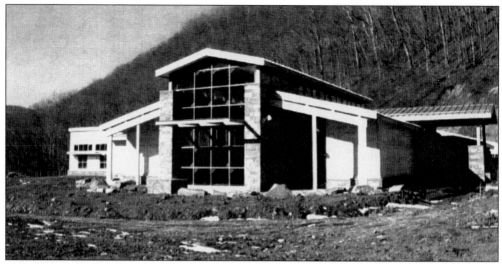

This January 2003 photograph shows the National Park Service's new Sandstone Visitor Center still under construction. The center, which opened in 2003, is located just off Interstate 64. The large one-story structure houses a spacious interactive exhibit area, a multi-purpose room for videos and school groups, a bookstore, and office space. The exhibits include information regarding the New River and its watershed and water quality. (Photograph courtesy of the National Park Service.)

ACKNOWLEDGMENTS

Many people helped me in compiling this pictorial history of Summers County. I wish to thank everyone for their assistance. Especially, I wish to thank my wife, Susan, for her help in many aspects of the book, her understanding, and her support. I am also grateful to Steve Trail for his help and guidance. I would like to express my appreciation to Steve McCoy, pilot, and Tom Bailey, photographer. Katy Miller, National Park Service librarian, was very helpful.

Others who made major contributions include Carla Ann Leslie; Randy Petry (Associated Photography of Princeton); Debra Basham, John Lilly, Alan Rowe, and Joanna Wilson (West Virginia Cultural Center); Jim Phillips (Pipestem State Park); Dorothy Jean Boley (Hinton Railroad Museum); Myra Zeigler, Melody Selvage, and Jenny Lynch (United States Postal Service); Kellan Sarles; Jim Costa; Donna Wykle; Bill Dillon; Bill Richmond; Charlie and Janis Boyd; Remona McMillon; V.E. Lilly; James R. Petry; Buzzy Hellems; Will and Joyce Meador; Suzanne Humphrey; Ruth Gwinn Tolley; Charles Woods; Bob Farley; and Steve Tassos.

INTRODUCTION

Summers County, located in southern West Virginia, is a rural county. Hinton, the county seat, is the only incorporated town.

Despite its small size in terms of population (approximately 13,000 in the year 2000) and area (368 square miles), Summers County is rich in natural beauty and history. The county lies on the Allegheny Plateau of the Appalachian Mountains and is dissected by three rivers—the New River, the Greenbrier, and Bluestone Rivers. The combination of mountains and rivers frequently results in spectacular vistas. In addition to many historic sites, Summers County has the most recorded archaeological locations among West Virginia's 55 counties.

In the formative years of the county, many individuals in the area were hard-working, self-reliant, independent, and talented. Those traits are still prevalent in the county's population of today.

The following list describes some of the significant events and trends in the history of Summers County.

13000 B.C. to A.D. 1700. Native Americans resided in the area of Summers County for thousands of years. Around 1700 A.D. the native dwellers relocated out of the area, returning only to hunt. White settlers first populated the land along the rivers in the mid-1700s. The arrival of the European descendants prevented the Indians from hunting freely as they once did.

1750–1751. Land companies facilitated settlements in the region. Dr. Thomas Walker led an expedition for the Loyal Land Company that explored present-day Kentucky and West Virginia. He noted the existence of settlements in the Greenbrier River Valley. John Lewis, on behalf of the Greenbrier Land Company, surveyed land along the Greenbrier River.

1753. Andrew Culbertson settled at Culbertson (later Crumps) Bottom on the New River. Due to the frequent threat of Indian attacks he left the next year.

1754–1763. During the French and Indian War, several forts were constructed in the area for the defense of the settlers.

1763. Indians massacred settlers at Muddy Creek, which is near the present boundary of Summers County. The English Crown issued the Proclamation of 1763 that prevented settlement west of the Appalachian Mountains. These two factors combined caused a depopulation of the area for several years.

1770. Col. James Graham, Samuel Gwinn, and others settled along the banks of the Greenbrier River.

1777. The Indians assaulted the Col. James Graham house. This attack was only one of many in the area during the year. Historians call this year "the year of the bloody sevens" because of the frequent Indian incursions.

1780–1850. During this period, there was an influx of settlers. At first, the pioneers settled primarily in valley bottoms. As their numbers increased, settlers moved to more rugged locations.

1861–1865. Most of the soldiers who lived in the part of western Virginia that ultimately became West Virginia fought for the Union during the Civil War. In sharp contrast, the vast majority of soldiers derived from the future Summers County were on the side of the Confederacy. Very few landowners in that area were slaveholders. There were a number of skirmishes in the area, but no major battles.

1863. The state of West Virginia was formed from the western part of Virginia.

1871. This year was the most significant in the history of the county for two very distinct reasons. First, the state legislature created Summers County from portions of Fayette, Greenbrier, Mercer, and Monroe Counties. (Summers County also borders Raleigh County.) The county was named for George W. Summers, a former member of the United States House of Representatives from Virginia. Second, the Chesapeake and Ohio (C&O) Railway Company built a major maintenance yard and purchased property in the present-day Hinton area. Soon afterwards, the C&O laid out streets, subdivided the land, and donated land for the construction of the county courthouse.

1873. The Great Bend Tunnel of the C&O was completed. It is the site where the legendary John Henry, the steel drivin' man, defeated the steam drill.

1873–1910. Hinton realized a boom in population and construction grew during this period. Hinton's population skyrocketed from a mere few hundred in the early 1870s to over 6,000 by 1907. The building that took place in the area was dynamic both in terms of rapid growth and architectural diversity. Building styles represented included English Gothic, American Gothic, Classical and Greek Revival, High Victorian, American Four Square, and Second Empire.

1880. The town of Hinton was incorporated into the county.

1890. The town of Avis was incorporated into the county.

1891. Mr. M.E. Ingalls, president of the C&O, gave the principal address at the opening of the YMCA in Hinton. This structure was the first of many YMCAs on the C&O line.

1902. *The Hinton Daily News*, the forerunner of the current *Hinton News*, was established.

1907. Builders constructed three impressive structures—the Masonic Temple, the McCreery Hotel, and the Big Four Building.

1917–1945. Hinton and Summers County were relatively prosperous during this period, dominated by the two World Wars and the Great Depression. The railroad served as the principal catalyst for the economic activity.

1927. The city of Hinton expanded to include Avis and Bellepoint.

1949. Operationally, the Bluestone Dam was completed. The Bluestone Lake was created.

EARLY 1950S. Bluestone State Park opened. Bluestone Lake, one of the largest lakes in West Virginia is noted for excellent fishing.

1950s. More efficient diesel engines replaced the steam engines on locomotives. Consequently, maintenance of engines was sharply reduced. This reduction, coupled with the increasing mechanization of coal mining, resulted in a sharp drop in railroad activity and employment in Hinton.

1970. Pipestem State Park—which was regarded by many as the premier state park in West Virginia—opened.

1978. As a unit of the National Park Service (NPS), Congress created the New River Gorge National River. The NPS protects and preserves a 53-mile stretch of the New River as a free flowing river in Summers, Raleigh, and Fayette Counties.

1984. Downtown Hinton was placed on the National Register of Historic Places.

1988. Engineers completed Interstate 64 through the northern portion of the county.

2003. The National Park Service opened a visitor center at Sandstone near Interstate 64.

One

THE SETTING

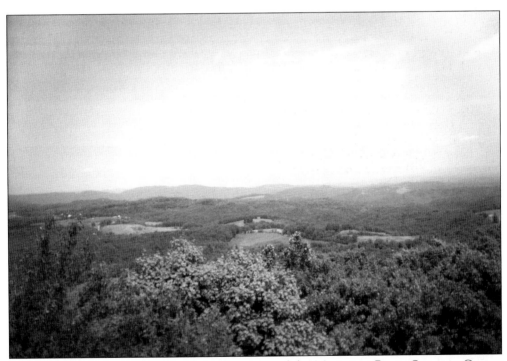

West Virginia is the most mountainous state east of the Mississippi River. Summers County contains more mountains than most counties in West Virginia. The area is dotted with a number of knobs, ridges, and mountains of 3,000 feet or more in elevation. The highest point in the county is slightly less than 4,000 feet. This photograph taken atop a tower on Pipestem Knob in Pipestem State Park shows a view of Summers County (Photograph courtesy of Susan Robinson.)

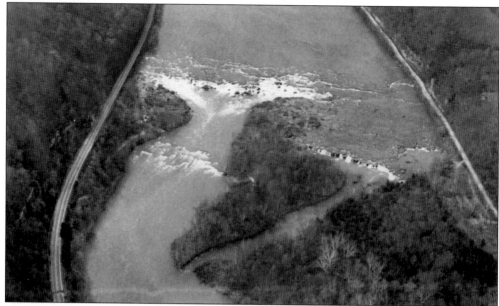

The aerial picture above shows the Sandstone Falls of the New River, which are in both Raleigh and Summers County. On the left lies Summers County. Despite its name, the New River has a very lengthy history. Some geologists regard it as the second-oldest river in the world, surpassed only by the Nile River in Africa. The river, millions of years old, partially follows the course of the ancient Teays River. Human habitation along the New River commenced thousands of years ago. Archaeologists have found evidence of Indian camps along the river's banks. The New River originates in Blowing Rock, North Carolina and flows north through Virginia into West Virginia. In 1978, Congress designated a 53-mile stretch of the New River, including a portion in Summers County, as a National River. The photograph below presents a ground-level view of the Sandstone Falls that reach 25 feet in height. (Photographs courtesy of the National Park Service and Susan Robinson.)

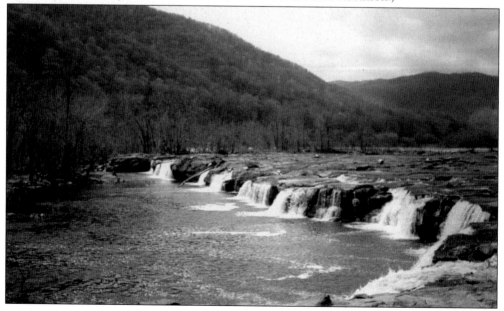

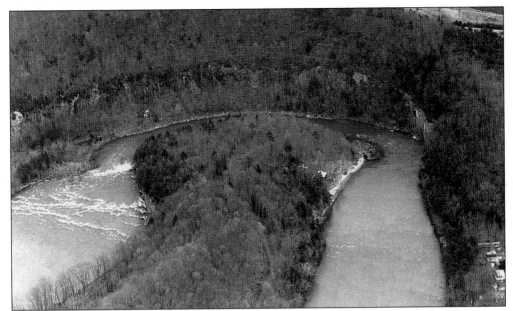

This photograph shows the big bend of the beautiful Greenbrier River. Within a few miles at Bellepoint, the Greenbrier merges with the New River. The origin of the name remains uncertain. Some historians believe the French named it "Ronce Verte," which translates to "green brier" in English. Others contend that around 1750, surveyor Thomas Lewis named the river. The elder Lewis regarded the river as the most beautiful he had ever seen. He referred to it as the "Lady of the Mountains." (Photograph courtesy of Tom Bailey.)

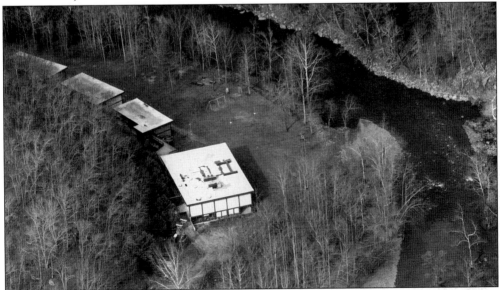

The Bluestone River starts in Tazewell County, Virginia and flows 77 miles to its confluence with the New River at Bluestone Lake, a few miles from Hinton. In 1988, Legislators designated a 10-mile segment of the Bluestone Gorge (between Pipestem and Bluestone State Parks) as a National Scenic River. This rugged gorge offers many spectacular views. This photograph shows the Bluestone River as it passes by the Mountain Creek Lodge at Pipestem State Park. (Photograph courtesy of Tom Bailey.)

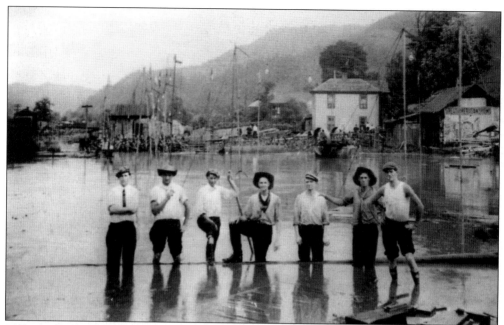

These carnival workers appear in high spirits as they posed for this picture during the flood of 1901 in Avis. The moods of residents who suffered losses of their homes and other property to the flood were much more somber. (Photograph courtesy of Steve Trail.)

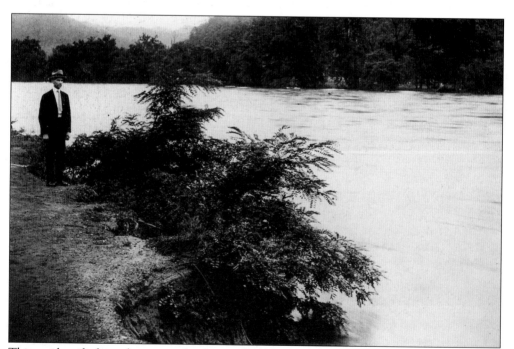

This unidentified gentleman resolutely watched the New River rapidly rise during the 1916 flood at Avis. During the height of the crisis, the river was rising at the rate of one foot per hour. (Photograph courtesy of Steve Trail.)

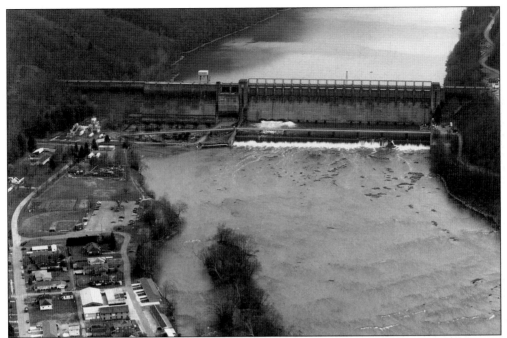

To deal with the frequent flooding, President Franklin D. Roosevelt issued a 1935 Executive Order that authorized construction of a dam. Work on the Bluestone Dam commenced in 1942. World War II interrupted the project. Work resumed in 1946, and the dam was completed for operational purposes in 1949. With the installation of crest gates, engineers totally completed the dam in 1952. Bluestone Dam has a height of 165 feet and a length of 2,048 feet. The residential area to the left on the picture is Bellepoint. (Photograph courtesy of Tom Bailey.)

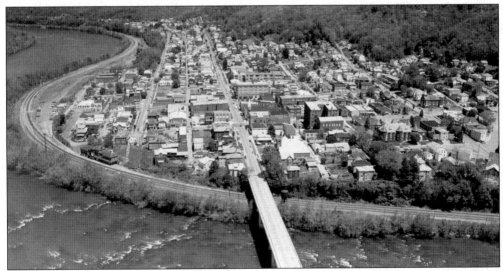

This photograph shows a recent aerial view of Hinton. Temple Street crosses the New River Bridge. The railroad depot is situated next to the railroad tracks on the left side of the photograph. The Big Four Building, the large building on the right side of Temple Street, is in the center of the picture). The Summers County Courthouse with its distinctive towers is on the right side of the photograph. (Photograph courtesy of Carla Ann Leslie.)

Dr. Bob Maslowski, an archaeologist, demonstrates pottery-making techniques at the 1987 Archaeology Day held at the National Park Service's Hinton Visitor Center. Many people in the county have a strong interest in archaeology. Summers County far surpasses any other county in the state for the number of archaeological sites. There are several reasons for Summers County's prominence of sites: Indians and white settlers tended to inhabit lands along rivers, and Summers County has three rivers. The construction of Bluestone Dam uncovered a number of sites. Also, Steve Trail, the county historian, has discovered hundreds of archaeological sites. (Photograph courtesy of the National Park Service.)

Two
TRANSPORTATION AND INDUSTRY

The rivers in Summers County have been a blessing to the community. At one time, the rivers represented serious obstacles to travel. Ferries were a partial answer to crossing rivers, but were dependent upon weather. In this 1926 photograph, Elmer Noble, operator of the Bull Falls Ferry, takes family members across the New River. Pictured left to right are the following: (front row) Quenton Noble, Lou Wood, Edith Wood Brooks, and Bill Noble (baby); (back row) John Quinn, Will Wood, Marjorie Quinn, Minnie Quinn, Elmer Noble, and Kelly Brooks. (Photograph courtesy of Joan Suiter.)

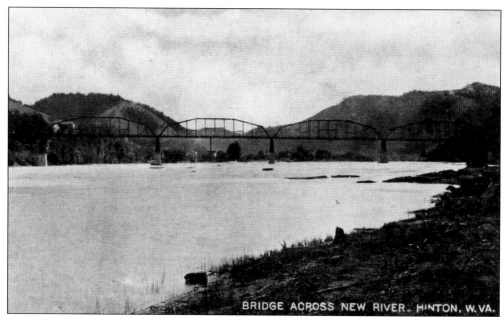

BRIDGE ACROSS NEW RIVER, HINTON, W. VA.

The construction of bridges helped to overcome the shortcomings of ferries. The Hinton Toll Bridge was completed in 1906. Tolls for a horse and rider or a pedestrian were 5¢ one way and 10¢ round trip. The charge for a two-horse buggy or car was 20¢ one way and 35¢ round trip. After 1935, the bridge no longer required a toll for those passing. A demolition crew dismantled the bridge in 1976, one year after the completion of the new Hinton New River Bridge. (Photograph courtesy of the National Park Service.)

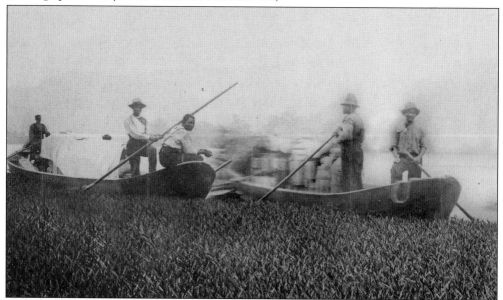

Because Hinton was a railroad hub and trading center, it became a river port as well. In the early 1900s, Hinton's importance as a river port declined. Hinton still remains the site of the annual West Virginia Water Festival. This photograph shows men in a keelboat or bateau on the New River. Boatmen used these flat-bottom boats to transport people as well as freight on the New and Greenbrier Rivers. (Photograph courtesy of the National Park Service.)

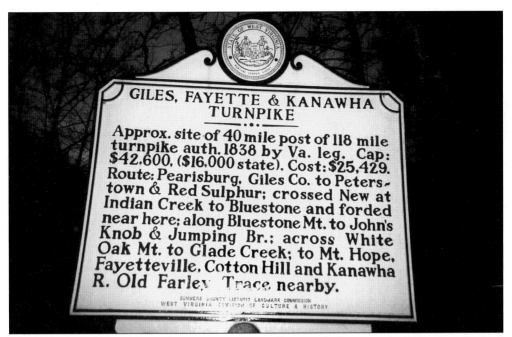

GILES, FAYETTE & KANAWHA TURNPIKE
• • •
Approx. site of 40 mile post of 118 mile turnpike auth. 1838 by Va. leg. Cap: $42,600, ($16,000 state). Cost: $25,429. Route: Pearisburg, Giles Co. to Peterstown & Red Sulphur; crossed New at Indian Creek to Bluestone and forded near here; along Bluestone Mt. to John's Knob & Jumping Br.; across White Oak Mt. to Glade Creek; to Mt. Hope, Fayetteville, Cotton Hill and Kanawha R. Old Farley Trace nearby.

SUMMERS COUNTY HISTORIC LANDMARK COMMISSION
WEST VIRGINIA DIVISION OF CULTURE & HISTORY

The Allegheny Mountains, the narrow steep valleys, and the rugged plateaus made road building in Summers County a difficult task. Early settlers built the first roads often at their own expense. Two of the first major roads constructed with state financing were the Giles, Fayette, Kanawha Turnpike and the Red Sulphur Springs Turnpike. As the above historic marker located in Bluestone State Park notes, construction crews built the road in 1838. In 1849, the state of Virginia authorized $4,200 for the construction of the Red Sulphur Turnpike. The road ran from Princeton in Mercer County through the future Summers County and ultimately to Red Sulphur Springs, a springs resort in Monroe County. After the Civil War, the popularity of Red Sulphur Springs plummeted. Shown below is the former Eskew home at Tophet located on the Red Sulphur Turnpike. (Photographs courtesy of Susan Robinson and the author.)

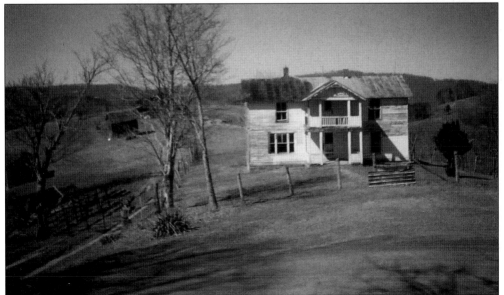

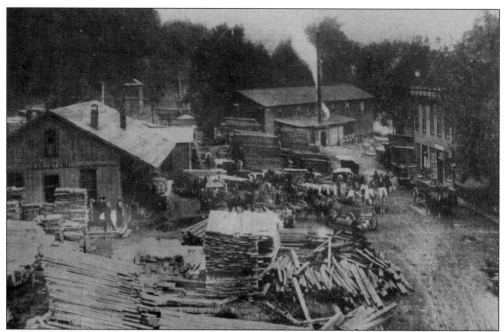

From the late 1800s to the 1930s, logging in Summers County was a significant industry. Extensive stands of virgin timber provided the raw materials for a large timber industry. John Graham and O.T. Honaker started this planning mill and lumber business at Sandstone. This photograph (c. 1907) shows the planning mill at Sandstone. The Sandstone Depot is on the left while O.T. Honaker's general store is on the right. (Photograph courtesy of Bill Richmond.)

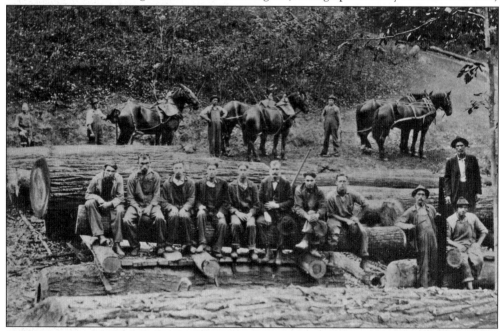

Shown here in a photograph (c. 1923) is a logging crew of the Meadow Creek Lumber Company. George Rorke is the man with the team of horses at the far right. (Photograph courtesy of the National Park Service.)

Longbottom was a small community in Raleigh County with a post office, homes, and a large logging operation in the 1920s and 1930s. The community did not have easy access to the railroad. The New River Lumber Company built this bridge to Summers County shown in the photograph to the right. The bridge had iron rods connected to steel cables and the bridge would dip when heavy lumber cars would go across. At Summers County, the C&O built this depot, shown below, named "Longbottom" and the train would pick up the lumber and transport it to market. (Photographs courtesy of the National Park Service.)

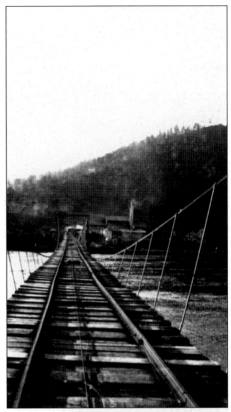

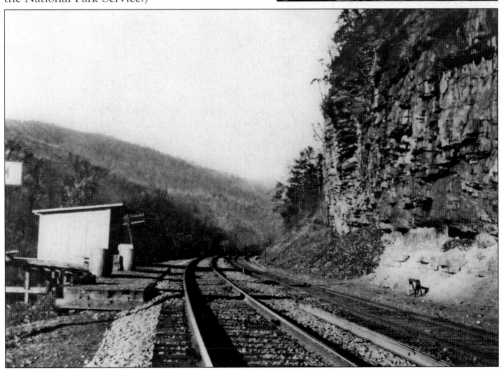

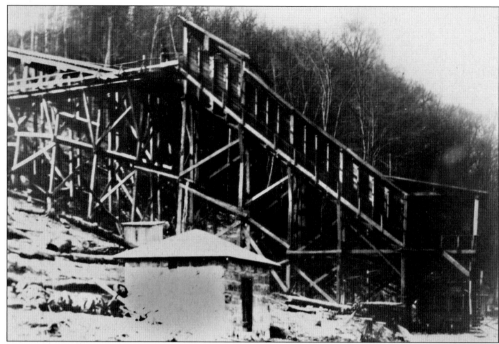

The volume of coal production in Summers County was considerably less than most counties in southern West Virginia. For many years, however, coal mining was active in Summers County. The top photograph shows a tipple at Hump Mountain in the northern part of the county. A tipple is a building that includes a rotary dumper for emptying mine cars used for bringing coal up from the mine. The picture below shows housing for Hump Mountain coal miners. (Photographs courtesy of the National Park Service.)

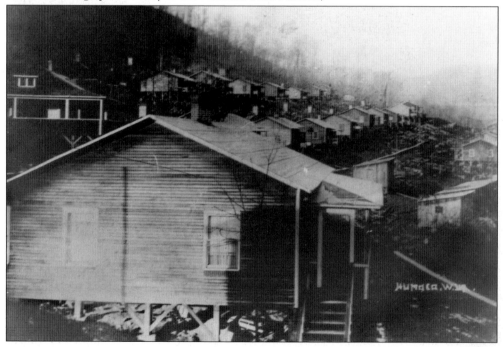

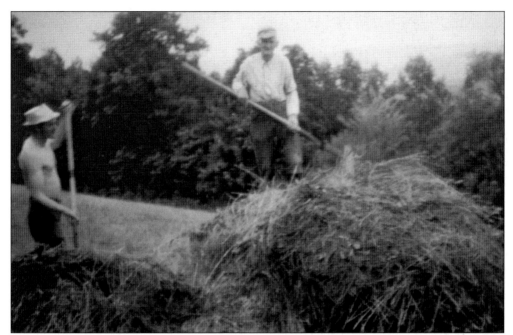

In the early 1900s, the primary occupation in Summers County and the United States was farming. Most of the farms in the county were relatively small. For instance, among the 2,000 farms in Summers County in 1910, two-thirds were less than 100 acres. Shown above are Will Hill and Bobby Hill bailing hay near Pipestem. In the bottom photograph, several people gather at a hog butchering (*c.* 1930) near the village of True. (Photographs courtesy of Pipestem State Park and the West Virginia State Archives, Steve Trail collection.)

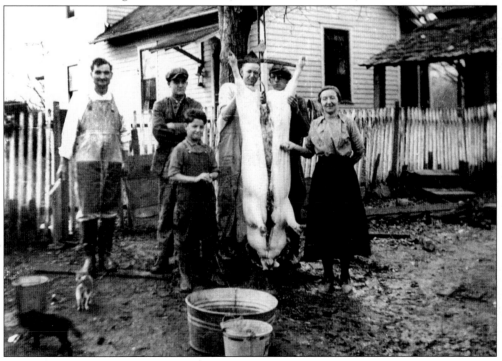

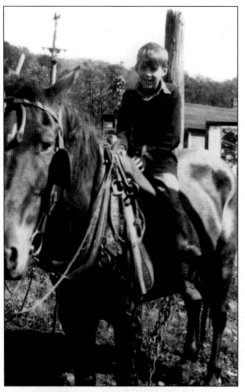

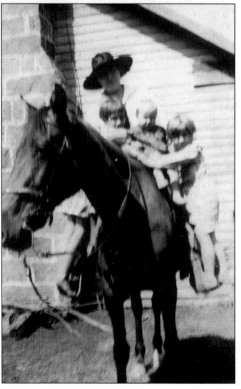

Before the popularity of cars in the region, horses were extremely important, particularly in rural areas. Farmers used them for plowing fields, hauling wagons, carrying goods, and for transportation. The top photograph (c. 1932) shows a young boy atop Donnie Gwinn's horse. Gwinn used the horse to carry mail from the train to the post office at Meadow Creek. People continued to ride horses for pleasure. The bottom picture (c. 1930) shows Mary Johnson and some children aboard a horse at a farm near Hilldale. (Photographs courtesy of the National Park Service and Brett Maddy.)

In March 1873, the Chesapeake and Ohio Railway (C&O) selected Hinton as a division terminal and maintenance shop site. For many years, the C&O Railway and the town of Hinton maintained a very close relationship. The C&O Railway purchased the Issac Ballengee farmland and laid out yard and shop facilities. In addition, the railroad purchased land and parceled out town lots. Hinton was a very advantageous location for the railroad. The C&O Railway could run its more powerful locomotives over the mountainous terrain east of Hinton. West of Hinton, the railroad could operate lighter locomotives on the more level terrain. Many railroaders found Hinton location convenient and decided to make their homes here. The C&O Railway was instrumental in making Hinton an important railroad town, boosting the local economy and freeing the county from previous physical isolation. This photograph shows Frank Cundiff, a railroad engineer, standing in front of the Issac Ballengee house. Ballengee was the first settler in Hinton. (Photograph courtesy of the National Park Service.)

During the "boom years" of railroad operations at Hinton, the roundhouse was active around the clock with several hundred employees. The railroad built the roundhouse in the 1890s. Originally, there were 17 stalls. In the early 1940s, the C&O Railway extended 14 of the existing stalls to accommodate the Mallet engines. In the 1950s, the more efficient cleaner diesels engine replaced the steam locomotives. The diesels required little maintenance, and roundhouse work crews were reduced sharply. Subsequently, 11 stalls were removed in 1957. This 1980 photograph shows the roundhouse only a few years before the railroad completely dismantled it in 1983. The large structure on the left is the coal dock where tender cars were loaded. (Photograph courtesy of the National Park Service.)

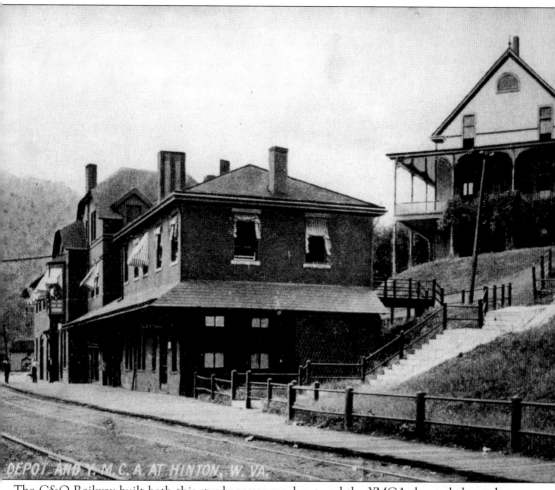

DEPOT AND Y. M. C. A. AT HINTON, W. VA.

The C&O Railway built both this sturdy passenger depot and the YMCA, located above the depot, in Hinton in 1891. This depot is the only one still standing in Summers County. The railroad used the building to house division offices as well as to perform regular depot functions. In the 1880s, promoters tried to convince C&O Railway president M.E. Ingalls to authorize the first YMCA on the C&O Railway line at Cincinnati. Ingalls was uncertain of the wisdom of the project and said, "Why don't you tackle Hinton instead of an easy place like Cincinnati." When asked where Hinton was, he replied, "It is a tough, forsaken place." Ingalls told the promoters if the Hinton project succeeded, he would support the construction of YMCAs at every C&O Railway division point. The C&O Railway president spoke at the dedication of the YMCA, and his address was regarded by many as a high point of the early history of Hinton. Ingalls became a strong advocate of the partnership between the railroad and the YMCA. This structure burned in 1911. (Photograph courtesy of the National Park Service.)

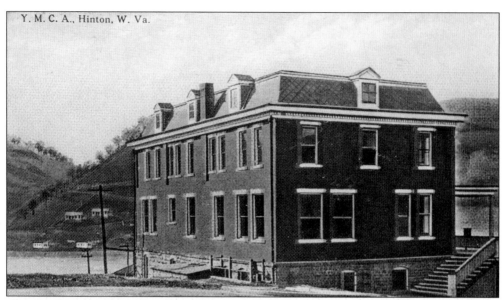

Construction crews built this brick YMCA building on the original site in 1913. It had reading rooms, game rooms, dormitory-style rooms for railroad employees, and offices. At one time, the membership rolls of the "Y" included 1,000 men. The "Y" served as a home for many railroad workers, who slept and relaxed here after a day's run. The game of checkers was often played by the railroaders during leisure time. Presently, the building serves as a senior center. (Photograph courtesy of the National Park Service.)

Railroad conductors posed for this 1899 photograph on the third floor of the Plumley Building in Hinton. The boy in front is Ray Faulconer. The conductor's lodge was one of the four lodges that help build the Big Four building in 1907. (Photograph courtesy of the Hinton Railroad Museum.)

26

This 1925 photograph shows electrician Peter Sentz changing light bulbs near the Hinton roundhouse. (Photograph courtesy of the National Park Service.)

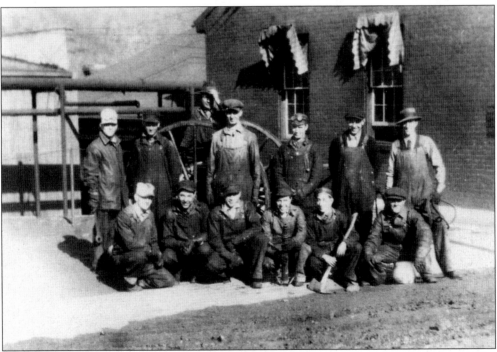

Fires were a frequent threat in the railroad yards; thus, the railroad formed fire brigades to fight the fires. This photograph shows the 1929 fire brigade at the master machinist's office in Hinton. Pictured from left to right are (front row) Harold Price, John Plumley, Meredith Nicely, Bob Womack, Lawrence Brooks, and Rube Donahue; (back row) Charles Boley, Arch Buckland, Eddie Briers, Joe Fitzsimmons, Bill Hutchinson, and Peter Sentz. (Photograph courtesy of the National Park Service.)

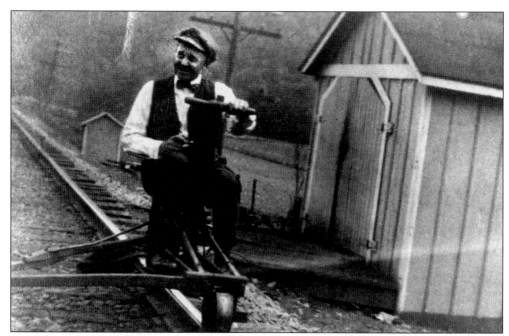

This unusual-looking device is a velocipede, derived from the French for "swift footed." This photograph shows a railroad employee at Brooks. The rider propelled the velocipede along the track by a combination of pulling and pushing the handles and pedaling. Velocipedes served an important function for railroad track inspectors, enabling them to quickly examine a section of track while remaining close to the track in order to see any potential difficulties. (Photograph courtesy of West Virginia State Archives, Hinton Railroad Museum collection.)

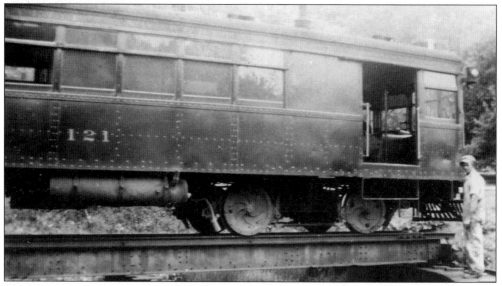

This photograph shows NF&G (Nicholas, Fayette and Greenbrier) car 121 (a "doodlebug") on the turntable at Meadow Creek. The man shown is helping the operator turn the car on the turntable. This former Sewell Valley car, built in 1923, became No. 121 on the NF&G and later C&O No. 9025. The C&O Railway retired the car in 1949. (Photograph courtesy of the National Park Service.)

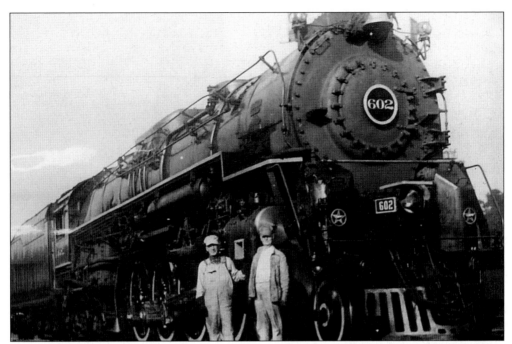

This photograph (c. 1940) shows engineer L.J. Brown Sr. (left) and fireman Lloyd Bryant standing next to Engine 602 in Hinton. (Photograph courtesy of India Brown.)

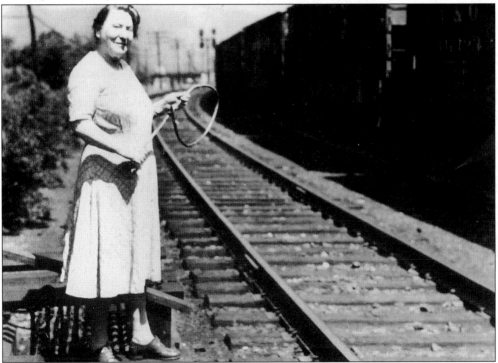

While men had the vast majority of railroad jobs, women also performed critical functions in the community. This 1943 photograph shows Mrs. E.M. Marable who was a telegraph operator in the Hinton area. (Photograph courtesy of the Hinton Railroad Museum.)

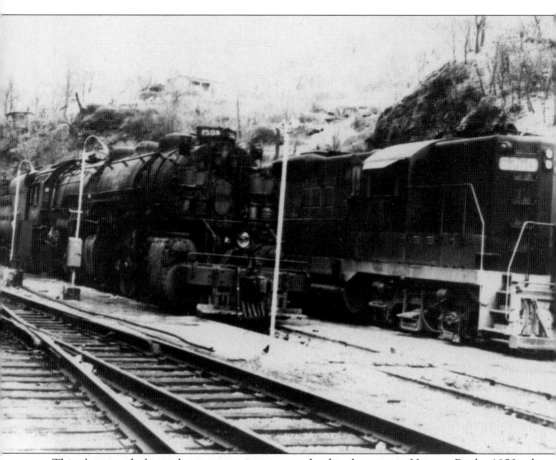

This photograph shows the steam engine next to the diesel engine in Hinton. By the 1950s, the more efficient diesel engine replaced the steam. This transformation had a profound and adverse effect on small railroad towns across America. During Hinton's heyday as a railroad town, the railroad employed over 1,000 workers. Presently, about 125 railroaders work in Hinton. In the early 1900s, Hinton averaged 6,000 freight cars monthly. Most of these were coal cars carrying coal out of the New River coalfields. In the early 20th century, nine passenger trains left Hinton daily. Currently, Amtrak's The Cardinal serves Hinton three times a week in each direction. (Photograph courtesy of the National Park Service.)

Three
INSTITUTIONS

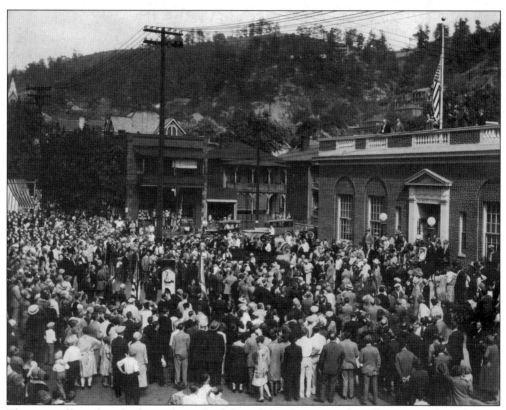

The post office played a key role in the life and development of small towns and rural areas. The post office served as a common bond that united neighbors and communities. As someone once remarked, "The post office isn't just for some people; it's for all of us." This impressive crowd, pictured here at the Hinton post office 1926 dedication is a testament to the importance of post offices in small towns and villages. (Photograph courtesy of the West Virginia State Archives, Steve Trail collection.)

Historic District of Hinton

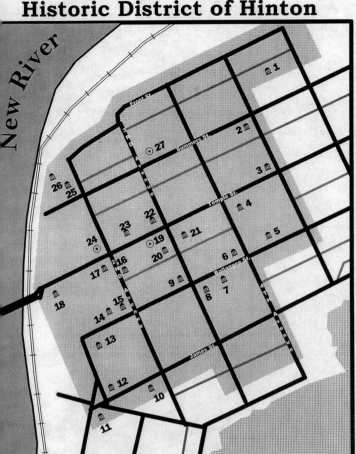

1. Freight Depot 2. Campbell- Flannagan- Murrell
3. Ascension Episcopal Church 4. Summers Middle
5. Carnegie Library 6. Charles Saunders House
7. J.M. Roles Home 8. First United Methodist Chu
9. First Presbyterian Church 10. Star House
11. Central Baptist Church 12. Memorial Building
13. Summers County Courthouse 14. Ewart- Mille
15. McCreery Hotel 16. St. Patrick's Catholic Chu
17. Citizens Bank Building 18. First Baptist Chur
19. Rose Building 20. Tomkies Department Store
21. Big Four Building 22. R.R. Flannagan Building
23. Lowe's Furniture Co. 24. Plumley Building
25. YMCA 26. C&O Train Station 27. Parker Opera

Locations of Historical Buildings
Locations of Demolished Historical Buildings
Streets of Hinton
Alleys of Hinton
Historic District

The National Register of Historic Places maintains the nation's list of cultural resources deemed worthy of preservation. The Register includes districts, sites, buildings, structures and objects significant in American history, architecture, archaeology, engineering, and culture. The shaded area on the map shows the Hinton Historic District placed on the Register in 1984. The locations of some of the more prominent structures of the 200 buildings in the district are also shown. Mr. Dunn, an engineer, named downtown Hinton's streets. The streets of Hinton and the reasons for their names are as follows: Front Street because it fronted the railway tracks; Summers Street for the county; Temple Street for Major Temple, one of the chief engineers who built the Chesapeake and Ohio Railroad; Ballengee Street for early settlers in the area by that name; and James Street for William James, a local lumberman. Mr. Dunn designated the cross streets as 1st, 2nd, and 3rd (etc.) Avenues. (Map courtesy of Jaime Wykle.)

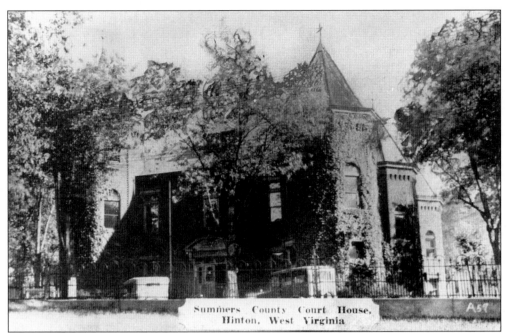

Summers County Court House,
Hinton, West Virginia

The C&O Railway donated a three-acre plot for the courthouse in Hinton. Workers constructed the original courthouse with local materials in 1875–1876. Architect Frank P. Milburn directed the rehabilitation and redesign of the building between 1893 and 1898. Four large octagonal towers were added to the corners of the structure. In 1923, two more towers were built and in 1934 the building was enlarged once again. Despite the extensive renovations over the years, the courthouse remains a striking and attractive large, red brick Victorian structure highlighted by the six symmetrical octagonal towers. (Photograph courtesy of the National Park Service.)

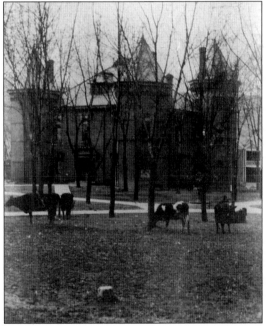

Despite the railroad and other industries in the community in 1906, Hinton was still in a transitional phase between rural community and urbanized town. This photograph shows cows grazing on the courthouse lawn. The city council passed an ordinance providing cattle had to be home by 8 p.m. or be subject to arrest. (Photograph courtesy of the National Park Service.)

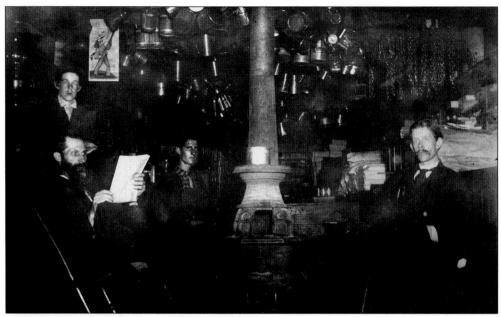

In the late 1800s and early 1900s, the general store played a critical part in the life of a community. An important role of the general store was that of "a meeting place." Men would sit around the pot-bellied stove during chilly days and discuss ideas, common problems, and the weather. Sometimes they would play checkers. This photograph shows the interior of the Silas Hinton general store that opened in Avis in 1871, the first in the area. (Photograph courtesy of the West Virginia State Archives, Jim Costa collection.)

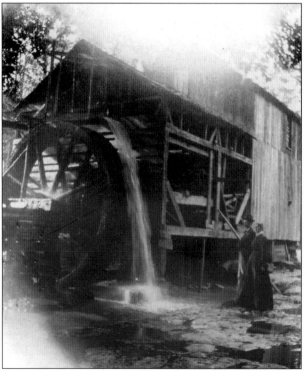

Shown here is the Bull Falls Mill near the New River. Mills were essential to the welfare of farmers in the 1800s and early 1900s. William Sanders, local historian, stressed in his book, A New River Heritage Volume II, the importance of mills. He cites that, according to Virginia law, the miller was exempt from military duty and jury service. These activities would prohibit the miller from operating his mill and thereby would deprive the community of bread and corn meal. (Photograph courtesy of the National Park Service.)

Silas Hinton, a son of John and Avis Gwinn Hinton, and his wife Mary Jane Charlton Hinton are associated with much of the history of Hinton. Their marriage on October 27, 1871, was the first in Hinton. Rev. Rufus Pack delivered the first sermon in Hinton in their home. They were among eight citizens who established the First Baptist Church, the first church in Hinton, in their home in 1872. (Photograph courtesy of the National Park Service.)

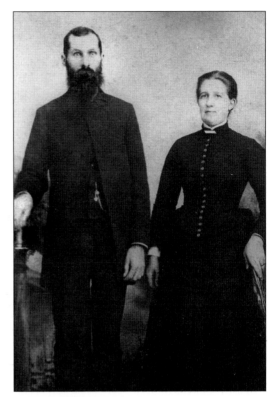

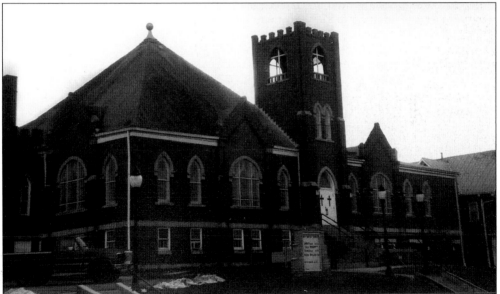

Silas and Mary Jane Hinton donated the land for the First Baptist Church and gave the church a central stained glass window. Workers completed the first church building in 1877. The Methodist and Presbyterian congregations worshipped in this church until separate structures were completed. Members dedicated the present church building in 1913 and installed a Mohler pipe organ in the same year. The large brick building is English Gothic in style. (Photograph courtesy of Jaime Wykle.)

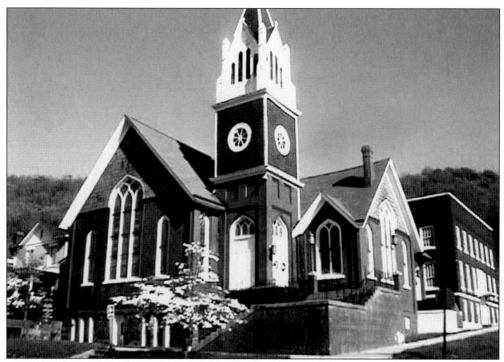

One of most outstanding features of downtown Hinton is the number of old, historic churches that represent a wide variety of architectural styles. Residents in Hinton established Baptist, Methodist, Episcopal, Presbyterian, and Catholic churches by the year 1874. Methodist members first met in 1872 in the temporary courthouse and then the uncompleted C&O Railway depot. The members laid the cornerstone of the First Methodist Church in 1894. Workers completed the structure in 1896. The building is of modified Gothic Revival design with a Gothic bell tower. (Photograph courtesy of Carla Ann Leslie.)

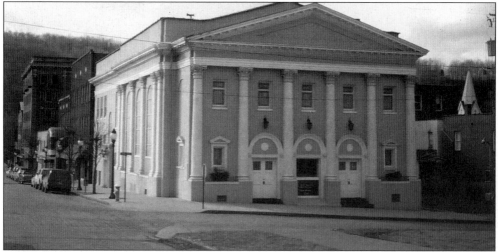

Six citizens of Hinton founded the Hinton Presbyterian Church in 1874. The first Presbyterian church was located on Temple Avenue. Builders completed the present church building—a large structure constructed in Greek revival style—in 1922. Six two-story Corinthian columns are in the front of the building. (Photograph by the author.)

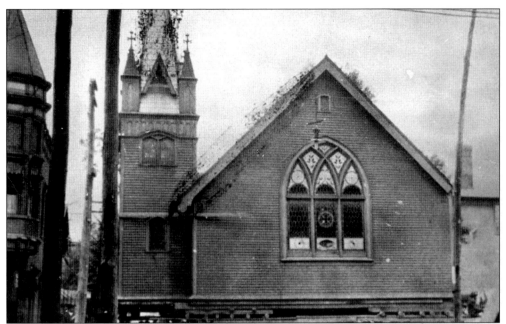

Interested citizens formed the Ascension Episcopal Church in Hinton in 1874. Workers completed the construction of a church building in 1881 at the corner of Temple and Third Street. A severe storm destroyed the church in 1897 and it was rebuilt the following year. In 1907, the church building was moved two blocks to Temple and Fifth Street due to the construction of the Big Four Building at the church's former location. The above photograph shows part of the church being transported. In 1929, workers covered the wood building with brick. The church's major architectural feature is the steeple that dominates a corner of the structure. The picture below shows a present view of the church. (Photographs courtesy of the National Park Service and Jaime Wykle.)

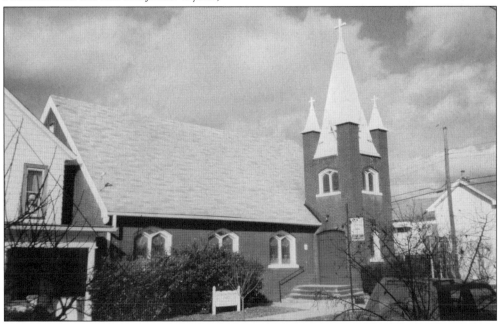

Father David Walsh, a native of Ireland, organized St. Patrick's Catholic Church in April 1874. The following month he purchased a lot bordering Temple Avenue and Second Street from the railroad for $100. The location proved to be one of the most desirable sites in Hinton. In 1878, Father Walsh erected a one-story house of worship. Father Walsh served as priest of the church until 1897. He ministered to all Catholics over a very large region covering several counties. (Photograph from the James Miller book *History of Summers County*.)

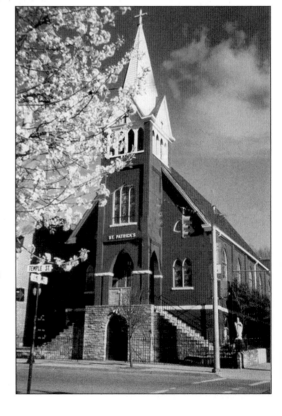

Father J.W. Werninger succeeded Father Walsh in 1897 as priest of St. Patrick's Catholic Church. Under his guidance, the present church was constructed in 1898. St. Patrick's is a brick Gothic Revival building. The bell tower is open in the bell area. In 1905, Father John J. Swint installed a 1,000-pound bell in the tower of the church. St. Patrick was the mother church of three missions. (Photograph courtesy of Carla Ann Leslie.)

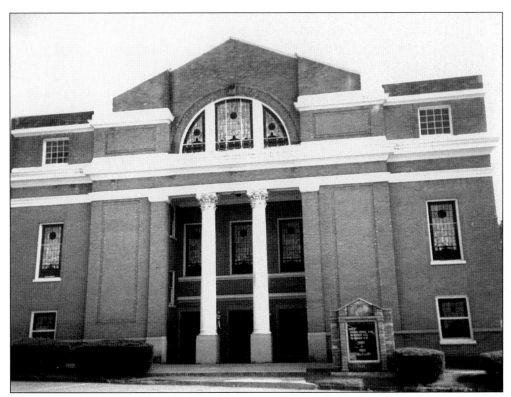

About 40 charter members established the Central Baptist Church in 1894. The congregation first met in the Parker Opera House. The church later purchased a lot on Ballengee Street and erected a frame structure. Work on the present church started in 1923 and was completed in 1925. On August 25, 1925, the congregation marched en masse from the church on Ballengee Street to the present location—about three blocks. The church is Neo-Classical in style with two massive Corinthian columns. (Photograph courtesy of Susan Robinson.)

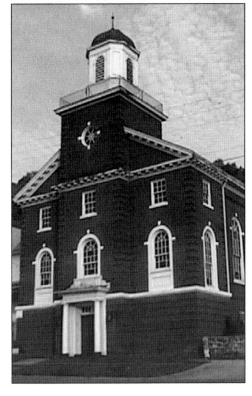

Rev. C.H. Payne organized the Second Baptist Church in the home of a Mrs. Hostler in 1878. The congregation met in homes of the congregation for several years until they erected a frame church. Church members laid the cornerstone of the church shown here in 1925 and it was dedicated in 1927. Regarded by builders as an outstanding example of Colonial Revival architecture, the church entrance has Tuscan columns. (Photograph courtesy of Carla Ann Leslie.)

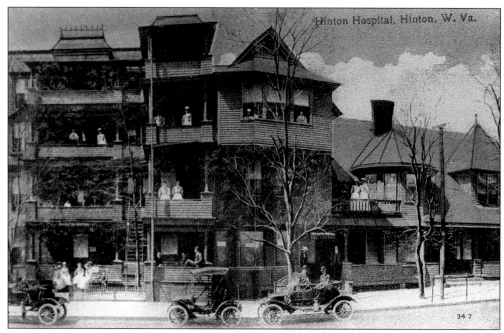

Dr. O.O. Cooper established the Hinton Hospital at Temple Street and Fourth Avenue in 1899. At the time, it was one of only three private hospitals in West Virginia. Dr. Cooper specialized in appendectomies and performed 3,000 of these surgeries. Around 1930, doctors moved the hospital across the street to the Big Four Building. Developers later converted the former hospital building to an apartment building. (Photograph courtesy of the National Park Service.)

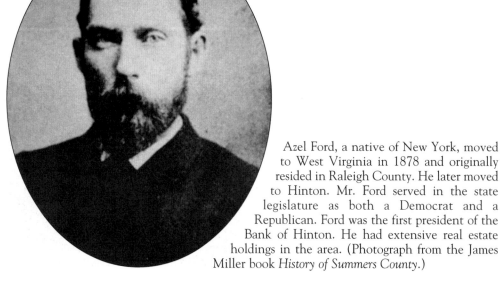

Azel Ford, a native of New York, moved to West Virginia in 1878 and originally resided in Raleigh County. He later moved to Hinton. Mr. Ford served in the state legislature as both a Democrat and a Republican. Ford was the first president of the Bank of Hinton. He had extensive real estate holdings in the area. (Photograph from the James Miller book *History of Summers County*.)

NUMBER 5562

The First National Ban
of Hinton, West Virginia

DESIGNATED DEPOSITORY OF THE STA
OF WEST VIRGINIA AND THE CHESAPEA
& OHIO RAILWAY COMPANY.

Accounts of Corporations
Firms and individuals solicited on the most liberal te
consistent with modern and careful banking.

Our Facilities
For handling your business promptly and satisfactorily
unexcelled, and it is our endeavor to extend to patr
every courtesy and accommodation.

Three per Cent. paid on Certificates of Deposit and in d
SAVINGS DEPARTMENT

DIRECTORS:

O. O. COOPER	AZEL FORD
JOSEPH HINTON	R. R. FLANAGAN
E. W. GRICE	S. O. FREDEKIN(
WM. PLUMLEY, JR.	T. M. DeSILV
M. L. COOK	

During most of Hinton's formative years, the town had three banking institutions. The oldest bank in Summers County, the Bank of Hinton, opened for business in 1887 with Azel Ford as president. In 1900, the bank became a national bank and its name changed to National Bank of Hinton. Bank officials moved the bank to Fourth and Temple in 1974. (Photograph courtesy of the National Park Service.)

The Bank of Summers opened in 1895. In 1905, the bank moved to a building with a distinctive turret on Temple Street across from the National Bank of Hinton. The building is eclectic in style with some details from the Classical Revival period. There are Ionic columns flanking the entrance doors. The building is significant because it is one of the few remaining structures on a corner in downtown Hinton. The first bank presidents were Harrison Gwinn (1895–1906), James T. McCreery (1906–1925), and James H. Miller (1925–1929). (Photograph courtesy of the National Park Service.)

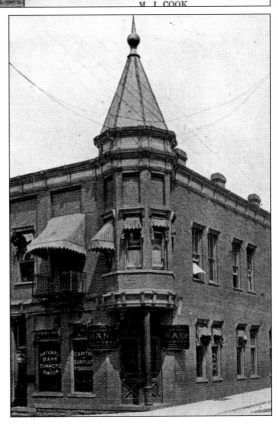

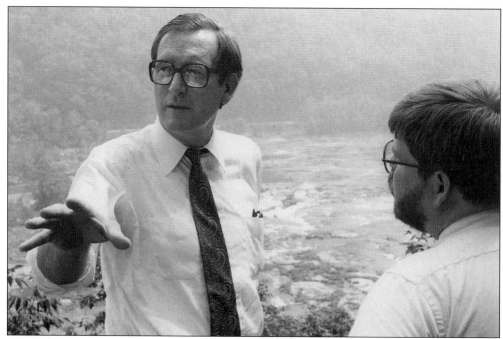

While standing above Sandstone Falls on the Raleigh County side, Sen. Jay Rockefeller and Bill Brezinski discuss issues regarding the New River. (Photograph courtesy of the National Park Service.)

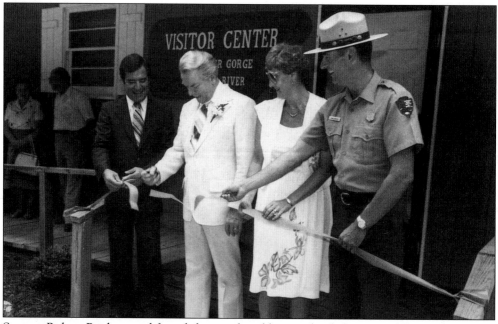

Senator Robert Byrd, second from left, cuts the ribbon at the dedication of the National Park Service's Hinton Visitor Center in 1983. Looking on are Congressman Nick Rahall, Emily Brier, and Jim Carrico. With the opening of the Sandstone Visitor Center in 2003, the National Park Service plans to close the Hinton facility. (Photograph courtesy of the National Park Service.)

Four

SPORTS AND
RECREATION

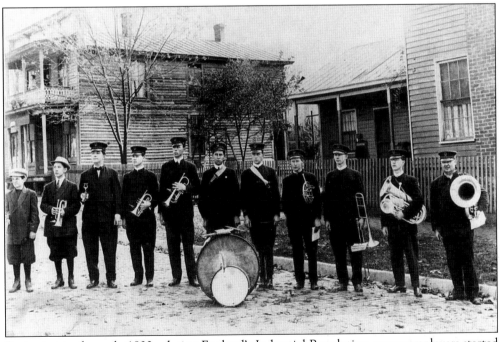

Beginning in the early 1800s, during England's Industrial Revolution, many employers started sponsoring brass bands for their employees. The company owners wished to increase employee morale as well as divert staff from political activity during their leisure time. Later, the popularity of brass bands spread to the United States. During the latter part of the nineteenth century and early 20th century, brass bands were tremendously popular in the United States. Shown in this photograph (*c.* 1900) is the Hinton band. (Photograph courtesy of West Virginia State Archives, Steve Trail collection.)

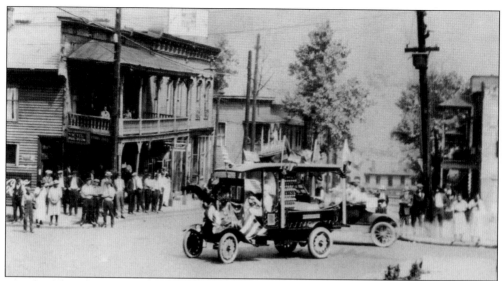

Residents of Summers County celebrate Independence Day with much enthusiasm. This photograph, taken at the corner of Temple Street and Third Avenue, shows part of a July fourth parade in Hinton (c. 1910). (Photograph courtesy of the National Park Service.)

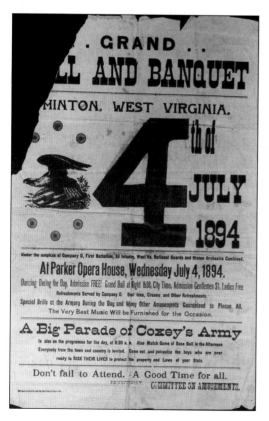

The Parker Opera House played an important role in the entertainment and social life of the community. Col. J.A. Parker opened the house in 1884. The facility closed around 1907. The Parker Opera House was the location of a wide array of activities including plays, speeches, parties, and various church social functions. Unfortunately, the gala advertised in the playbill for July 4, 1894, ended in disaster. The Opera House was filled to capacity and a balcony collapsed, killing a boy and injuring several others. (Photograph courtesy of the National Park Service.)

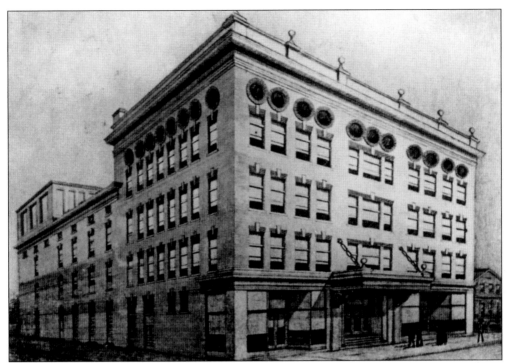

This artist's drawing shows Hinton's impressive Masonic Temple Theatre built in 1907. The front part of the building contained four stories. Several retail businesses occupied the first floor while the second floor provided residential apartments. The lodge's dining hall was on the third floor and the lodge's meeting hall comprised the fourth floor. In the rear was a three-story theatre with two balconies. For many years, the Masonic Theatre provided Summers County residents quality entertainment. The Masonic Theatre literally was a big city theatre in a small town. (Photograph courtesy of the National Park Service.)

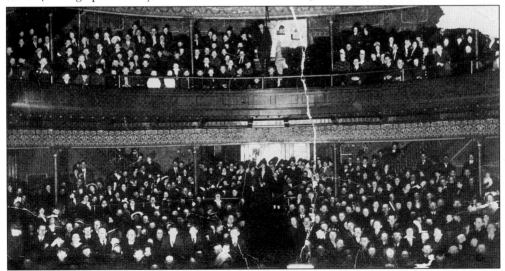

Shown here is a Masonic Theatre audience at a play. During the 1910s, members of the audience would be attired with the ladies in evening gowns and men in tuxedos. (Photograph courtesy of the West Virginia State Archives, H.F. Cooper collection.)

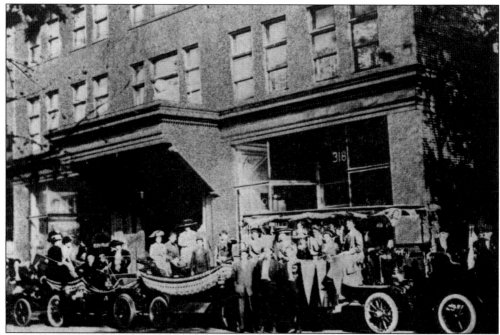

This photograph (c. 1910) presents the Wellington Opera Troupe in front of the Masonic Theatre. For many years, a host of well-known performers and personalities appeared at the theatre including William Jennings Bryan, evangelist Billy Sunday, and Blackstone the magician. (Photograph courtesy of the National Park Service.)

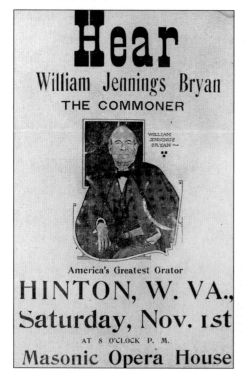

This 1924 playbill announces the upcoming appearance of William Jennings Bryan at the Masonic Theatre. Bryan was extremely popular in Hinton. Interested spectators filled the Masonic theatre to capacity to hear Bryan's address. Hundreds of others were turned away due to the lack of space. At that time, this was one of the largest crowds ever to gather in Hinton. (Photograph courtesy of the National Park Service.)

Maryat Lee, writer, artist, and musician, was born in Kentucky in 1923. She moved to Summers County in 1971. Lee established EcoTheatre, a theatre with mountain themes performed by local people. One of the goals of her EcoTheatre was to provide people, who otherwise would not attend the theatre, an opportunity to do so. As a result, EcoTheatre has staged productions in a wide variety of venues—prisons, hotels, schools, state parks, flea markets, grassy meadows, and at Bluestone Dam. (Photograph courtesy of Martha Asbury.)

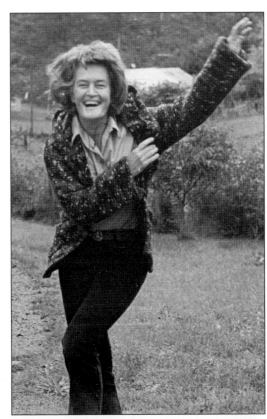

The first play that EcoTheatre created was entitled *John Henry*. Its initial production was in 1975. Noted actor Ossie Davis attended one of the performances of *John Henry*. Other plays based on local history and local people include *Old Miz Dacey* and *A Double Threaded Life: The Hinton Play*, a story focused on the adverse impact a dwindling railroad presence had on the town of Hinton. (Photograph courtesy of Martha Asbury.)

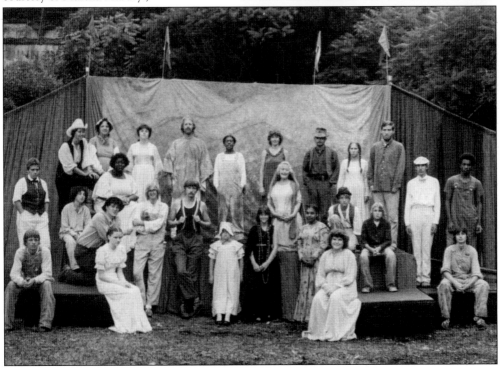

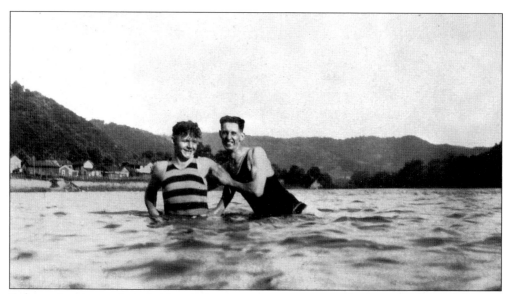

Before swimming pools were common, swimming in rivers was a favorite summertime activity. This 1925 photograph shows "Ram" Harford and "Moody" Burdette enjoying a dip in the New River near Avis. (Photograph courtesy of National Park Service.)

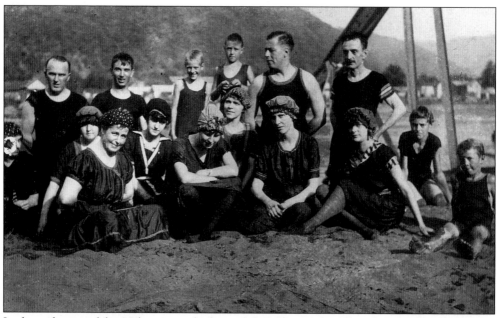

In the early part of the 20th century, bathing clubs were popular. This photograph, taken about 1910, shows the latest in swimwear for the time. Times have changed! (Photograph courtesy of West Virginia State Archives, Jim Costa collection.)

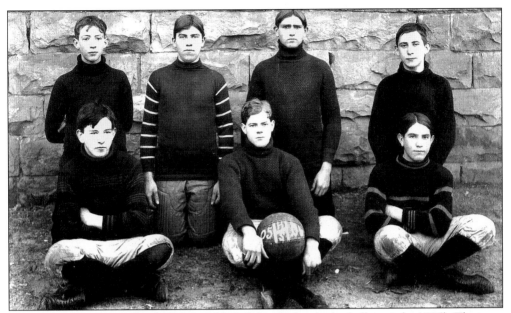

These players were members of Hinton High School's first basketball team (*c.* 1905). They are, left to right, as follows: (front row) two unidentified and Charles Frederick Boley; (back row) unidentified, Owen Miller, unidentified, and Carl Fredeking. (Photograph courtesy of Dorothy Jean Boley.)

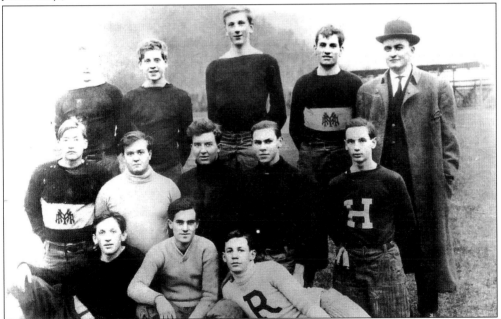

The members of an early Hinton High School football team, shown here from left to right, are as follows: (front row) B.B. "Bennie" Bryant, Howard Saunders, and Linden Dotson; (middle row) Eugene Briers, Oscar Griggs, Charles Boland, Clyde Johnson, and Charley Alley; (third row) H.C. "Fats" Foster, Armsteed Early, Paul Heflin, H. Riddleberger, and Coach R.L. "King" Cole. During World War I, Heflin was killed in action. (Photograph courtesy of Buzzy Hellems.)

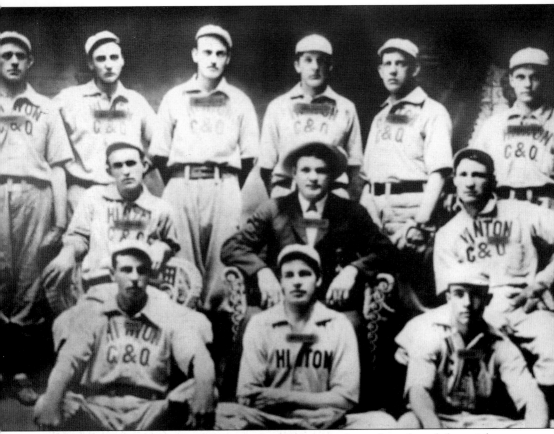

The 1905 members of the C&O Hinton baseball team, shown here from left to right, are as follows: (front row) John Day, Bob Murrell, and John Hobbs; (middle row) ? Thomas, ? Marton, and "Cabbage" Wise; (back row) ? Turner, Bill Maxwell, Joe McCarthy, "Compound" Chandler, ? Fox, and ? Starbuck. During the late 1800s and early 1900s, baseball was by far the favorite sport in America. Many towns across America had teams, and Hinton was a baseball hotbed. From 1895 to 1914, the Hinton C&O team "was big league." After his stint with the Hinton team, Jack Wauhop (Warhop) played eight years in the major leagues. In 1898, the Hinton team tied the Cincinnati Redlegs, managed by the immortal Clark Griffith, in a 14-inning exhibition game. They competed against Hall of Famer Christy Mathewson. Their winning streak included defeats of numerous college teams and teams from much larger towns. In 1899, they played the University of Kentucky in three separate games, winning each time. The team sometimes traveled in a unique fashion. The story of their travels on a hay wagon and also by boat were often told by the residents of Hinton. (Photograph courtesy of Hinton Railroad Museum.)

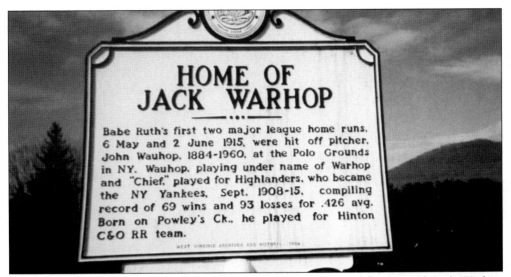

HOME OF JACK WARHOP

Babe Ruth's first two major league home runs, 6 May and 2 June 1915, were hit off pitcher, John Wauhop, 1884-1960, at the Polo Grounds in NY. Wauhop, playing under name of Warhop and "Chief," played for Highlanders, who became the NY Yankees, Sept. 1908-15, compiling record of 69 wins and 93 losses for .426 avg. Born on Powley's Ck., he played for Hinton C&O RR team.

WEST VIRGINIA ARCHIVES AND HISTORY 1998

Despite playing for weak teams and recording an unimpressive win/loss record, Jack Warhop posted a respectable 3.12 earned run average during his eight years spent in the major leagues. Many baseball fans considered him a hard-luck pitcher but a feisty competitor. He confronted batters with a very difficult underhand delivery and good control. His claim to fame occurred on May 6, 1915, while pitching against the Boston Red Sox. The opposing pitcher, the legendary Babe Ruth, blasted one of Warhop's pitches for his first career home run. (Photograph courtesy of Susan Robinson.)

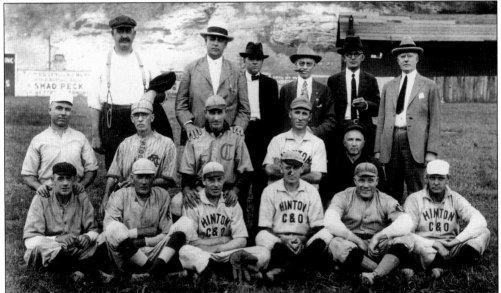

The 1921 C&O baseball team, shown from left to right, are (front row) Bill Turner (engineer), Compound Chandler (conductor), Bob Murrell (conductor), Joe McCarthy (conductor), Bill Farrell, and Harry Starbuck (engineer); (middle row) John Hobbs, John Day (conductor), Sheff Moore, Elvin Wise (conductor), and Charles McWhorter; (back row) J.R. Curry, H. Talley Brown (superintendent, Hinton Division), John D. Germer (dispatcher, Hinton Division). C.S. Faulconer (Assistant Superintendent, Hinton Division), and Charley Lake. (Photograph courtesy of West Virginia State Archives, Hinton Railroad Museum collection.)

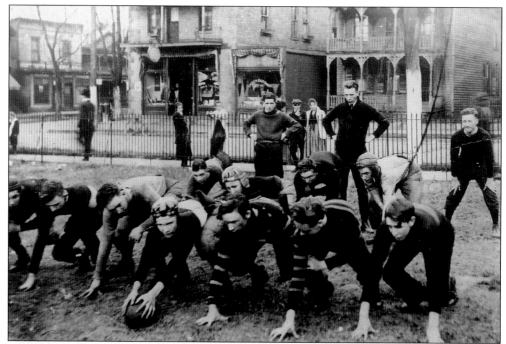

This c. 1918 photograph is of Hinton High School's football team. Players, from left to right, are (front row) Cecil Hall, Oscar Quesenberry, Frank Pierce, Bill Gardner, Fred Brown, Les Ratiff, and Jim Russell; (middle row) Maurice Templeton, John Parry, Dick Noel, and Frank Johnson; (back row) John Cobb, Ernest Graham, and Worth Wray. Before the construction of the post office, a portion of Courthouse Park was used as a practice field. (Photograph courtesy of Steve Tassos, Bobcat Den.)

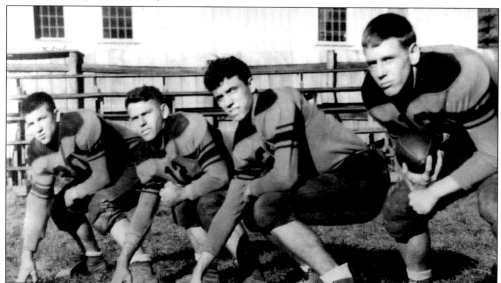

The 1947 Hinton High School team was one of the finest in school history. They captured 10 straight wins but lost their final game. This photograph shows the starting backfield. Pictured left to right are Jack Westfall, Bobby Jack Crush, Lloyd "Buck" Seldonridge, and Pat Shires. (Photograph courtesy of Buzzy Hellems.)

The Kennedy Award is given annually to West Virginia's best high school football player. Although Hinton High is a relatively small school, they boast two winners of the prestigious award. Pat Shires was the first recipient of the Kennedy Award in 1947. Pat Shires attended the University of Tennessee and was a member of the Volunteer powerhouse teams of the early 1950s. In the 1951 Cotton Bowl, he booted two extra points in the Volunteers' 20-14 victory over Texas. Shires was Tennessee's first team tailback in 1952. (Photograph courtesy Steve Tassos, Bobcat Den.)

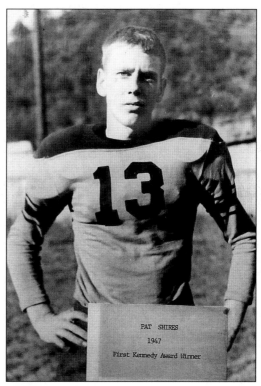

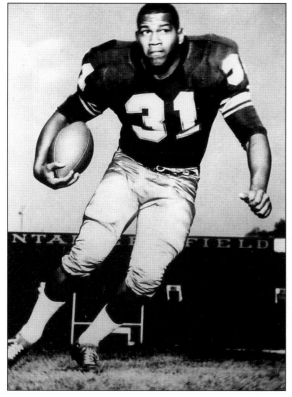

Dick Leftridge was one the greatest football players in Hinton High School's history. He won the 1961 Kennedy Award and was second in scoring in the state. Later in his career, he starred for West Virginia University and was a first-round draft pick of the Pittsburgh Steelers. (Photograph courtesy of Steve Tassos, Bobcat Den.)

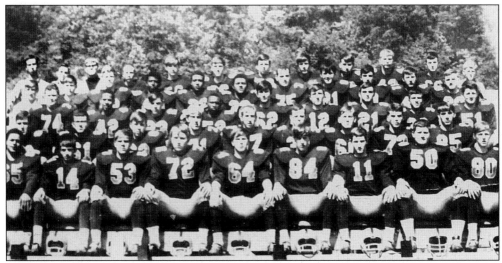

The Hinton (and after 1994 Summers County) High School Bobcats have a rich football tradition. Shown here is the 1968 state championship team. The Bobcats also captured the state championship in 1937. They were runners-up in 1963. (Photograph courtesy of Steve Tassos, Bobcat Den.)

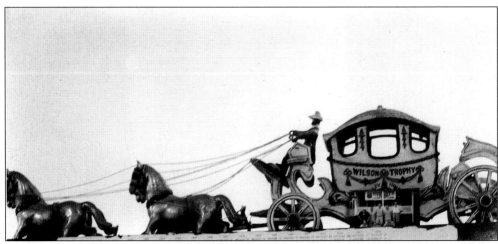

From 1932 to 1972, the Hinton High School Bobcats and Woodrow Wilson High School of Beckley in neighboring Raleigh County battled for the Wilson trophy shown above. The teams usually played on Thanksgiving Day, and the games frequently drew thousands of fans despite adverse weather conditions. In the latter years of the series, the Beckley school grew to be one of the largest schools in the state while Hinton High remained a much smaller school.

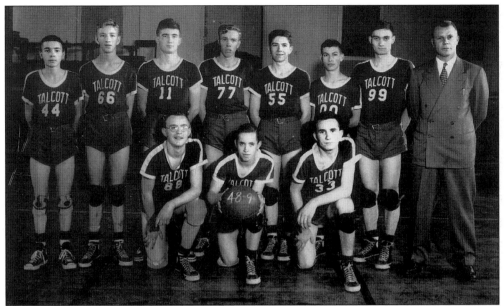

The members of the 1948–1949 Talcott Pirate basketball team, shown here from left to right, are (front row) Benny Sowers, Jim Nelson, and Richard "Sonny" Chattin; (back row) Tom Akers, Frank "Junior" Buckland, Bill Boyd, Donald Maddy, John Allen, Bob Huston, Jerry Bartgis, and Coach James Porterfield. Later in his career, Porterfield coached at Hinton High School. (Photograph courtesy of Steve Trail.)

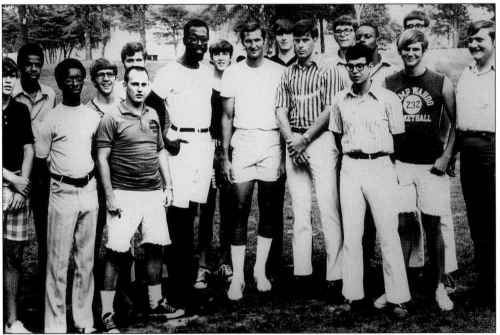

The Hinton High School basketball team gathers around NBA basketball players Jerry West, a West Virginia native, and Tom "Satch" Sanders at a 1971 summer camp. West is an all-time West Virginia University and Los Angeles Laker great. Sanders starred with the Boston Celtics. (Photograph courtesy of the West Virginia State Archives, Linville Goins collection.)

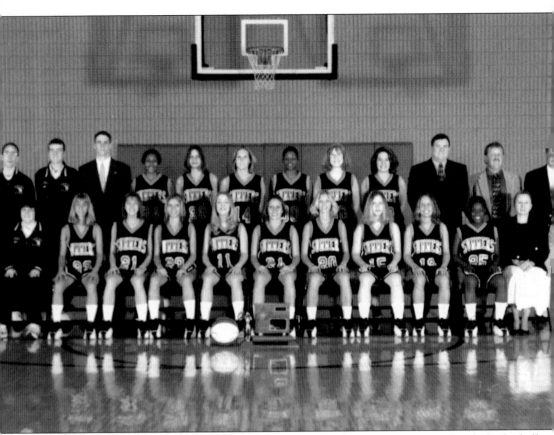

The Summers High School (and formerly Hinton High School, prior to 1994) girl's basketball team is a perennial Class AA powerhouse. From 1988 to 2000, they reached the state tournament every year. The Lady Bobcats captured the state title in 1988, 1992, 1994, and 2000. They were in the finals in 1989. This photograph shows the coaches, support staff, and players of the 2000 team that compiled a 23-5 record en route to the state title. Pictured from left to right are as follows: (front row) Cathy Richmond, Laura Kirkham, Kelli Rudisill, Megan Milburn, Amanda Williams, Megan Allen, Jamie Keatley, Brandi Basham, Jessie Mills, Kari Standard, and Lynn Crowder; (back row) Lee Whitten, John Richmond, Derek Emerson, Carman Wynes, Amy Bowling, Brandi Mills, Nikki Jackson, Katie Payne, Yansea Hutchens, head coach Wayne Ryan, Robbie Meador, and Doug Trail. On this team, Amanda Williams received all state honors. Brandi Basham and Amy Bowling received similar recognition on subsequent teams. Many individuals in this photograph are descendants of early settlers of Summers County. (Photograph courtesy of Wayne Ryan.)

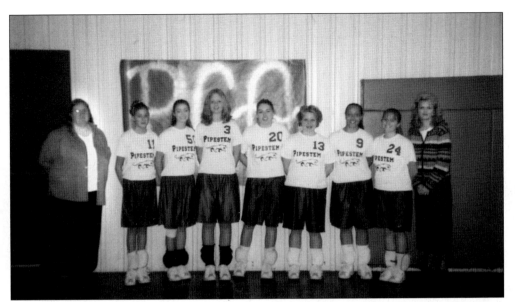

The Pipestem Christian Academy competes in the West Virginia Christian Education Association. The Lady Panther volleyball team has captured state championships in 1999, 2000, 2001, and 2002. They have won 66 of their last 67 matches. Members of the 2002 team left to right include the following: Assistant Coach Amanda Phillips, Brittany Mansfield, Manda Phillips, Loni Krieg, Jennifer Spangler, Kala McCoy, Lindsay Brown, Melinda Kinzer, and Coach Cindy Peyton. (Photograph courtesy of Cindy Peyton.)

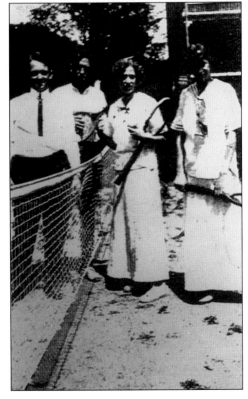

This c. 1910 photograph shows tennis players at the Barger Springs Hotel courts. In the early 1900s, patrons of the Barger Springs and Pence Springs Hotels were afforded a wide range of recreational opportunities. (Photograph courtesy of Dillon's Superette, Talcott Memorabilia Room, Jim Costa Collection.)

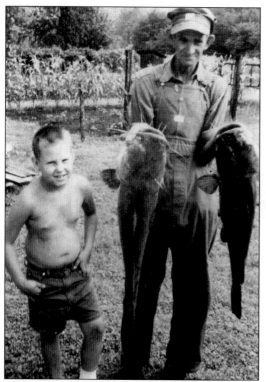

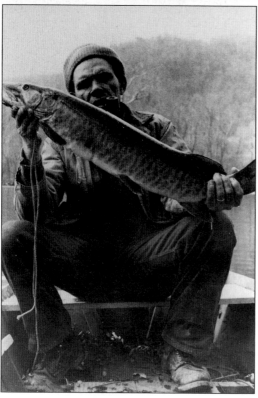

Fishermen flock to the waters of Summers County, noted for its excellent fishing. Species of fish found in the county include the following: smallmouth bass, largemouth bass, hybrid stripped bass, catfish, crappie, sunfish, muskie, and walleye. In the top photograph Donnie Gwinn of Meadow Creek and a young boy display two catfish caught in the New River. Shown below is Carlton Cox, a Hinton fireman, with a muskie. Cox was noted for his big catches. In 1967, he landed 39- and 36-inch muskies and a state record 16-pound, 3-ounce walleye. Carlton also caught a 29-pound, 5-ounce mudcat. (Photographs courtesy of the National Park Service.)

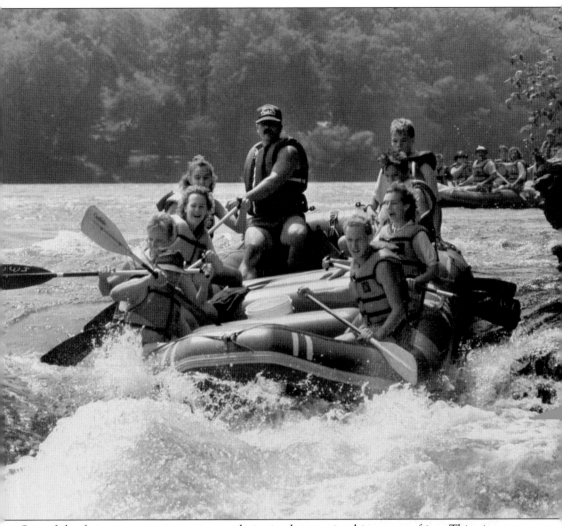

One of the fastest growing sports in popularity in the area is whitewater rafting. This picture shows Chris Hersman, a Hinton native, guiding a group of girl scouts over the Brooks Falls of the New River, one of the favorite rivers of whitewater enthusiasts in the eastern United States. This portion of the river is rated Class III in difficulty—waves up to four feet with obstructions. (Photograph courtesy of Chris Hersman.)

Many West Virginians enjoy hunting. The picture to the left shows Norman Jones, a resident of neighboring Mercer County, proudly exhibiting a turkey, shot at his hunting property in Summers County near Forest Hill. In the photograph below, Greg Dalton, Jones's son-in-law, displays a deer he bagged at the Jones property. (Photographs courtesy of Norman Jones.)

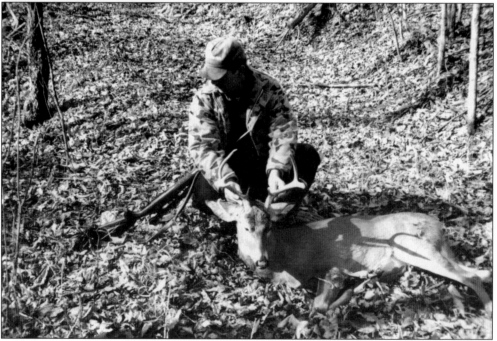

Five

FOREST HILL DISTRICT

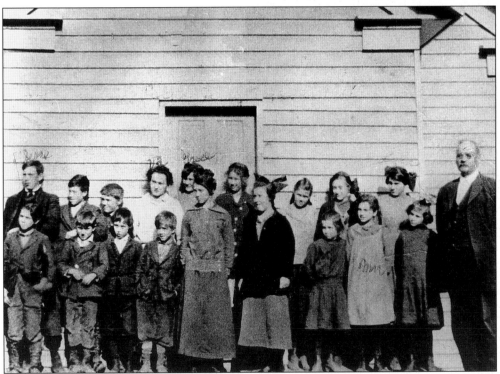

Big George Lilly stands with the 1912 class at the Packs Ferry School. With an appropriate nickname, he stood six-feet-six-inches tall and weighed 250 pounds. Lilly, a respected educator, served two terms as county school superintendent. Packs Ferry was one of the oldest communities in the area. Postal authorities established a post office at Packs Ferry in 1840, the first in the future Summers County. The Bluestone Dam project forced abandonment of the village in the 1940s. (Photograph courtesy of West Virginia State Archives, Steve Trail collection.)

This photograph shows Rebecca Peters Pack, who was the daughter-in-law of Samuel pack. He established Packs ferry at the mouth of the Bluestone River. This ferry was the first in the county. (Photograph from the James Miller book *History of Summers County*.)

Rev. A.D. Bolton was a Baptist minister for 40 years. He resided in Forest Hill District for over 20 years until his death in 1899. He preached at Forest Hill's Fairview Church as well as in the communities of Talcott and Indian Mills. He was highly regarded by all of his parishoners. (Photograph from the James Miller book *History of Summers County*.)

Josephus Pack was the son of one of the early settlers of Summers County. He served as the first county clerk of Summers County. (Photograph from the James Miller book *History of Summers County*.)

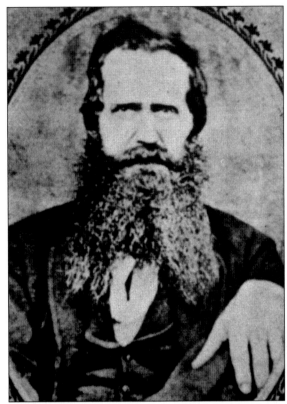

This photograph (*c.* 1910) shows these smartly attired hunters, hunting close to Forest Hill. (Photograph courtesy of Steve Trail.)

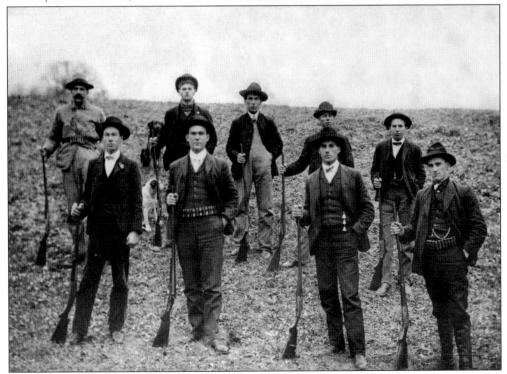

The beautiful farming community of Forest Hill boasts two historic churches—The Methodist Church of Forest Hill (shown to the left) and Fairview Baptist Church (shown below). It is amazing that a village this size (population of 80—based on the 2000 census) has two such historic churches. The Forest Hill Methodist Church was established in 1835. In 1863, during the Civil War, two future United States presidents, Rutherford B. Hayes and William McKinley, stayed at this church location for several days. Twenty-five residents established the Little Wolf Baptist Church in 1859. Its name was later changed to Fairview Baptist Church. In 1907, old comrades and former Confederate soldiers erected a monument to Mike Foster in the Baptist Church cemetery. During the Civil War, Confederate Gen. Thomas "Stonewall" Jackson had regarded Foster as the bravest man he knew. Three thousand people attended his memorial service. This crowd was one of the largest in the history of Summers County. (Photographs courtesy of Susan Robinson and author.)

Comrades and friends erected this memorial to Mike Foster in 1907. The grave marker is this impressive 10-foot shaft. Prayers and tributes to the Confederate soldier and music marked the October day of the unveiling of the monument. Foster, a sharp-shooter, fought in many Civil War battles and distinguished himself through bravery and courage. (Photograph courtesy of Susan Robinson.)

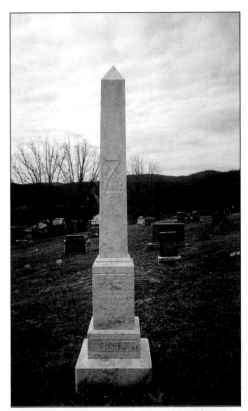

This gathering is a 1907 reunion of Confederate soldiers in Forest Hill. (Photograph courtesy of the West Virginia State Archives, Steve Trail Collection.)

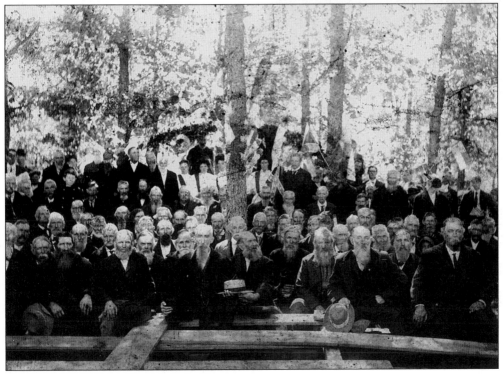

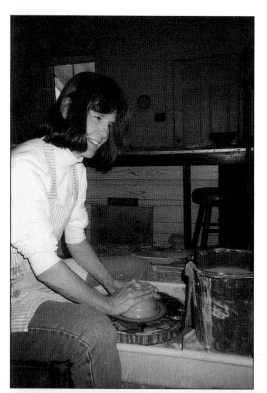

Marcia Springston of Forest Hill has been creating pottery since 1975. She has exhibited her pottery throughout the United States and Canada. Springston, blind since birth, describes her creative approach to her art form with this philosophy: "My hands remember how the pots grew, and my heart is gratified." (Photograph courtesy of Susan Robinson.)

Dr. James Blume was selected National Country Doctor of the Year in 2002. Although his office is in the tiny village of Forest Hill, he treats 7,000 patients annually. Forest Hill remains the smallest community in West Virginia with a full-time medical practice. This picture shows Dr. Blume with his wife, Sally, and their sixth of seven children, Bryanna, at the award ceremony. (Photograph courtesy of Sally Blume.)

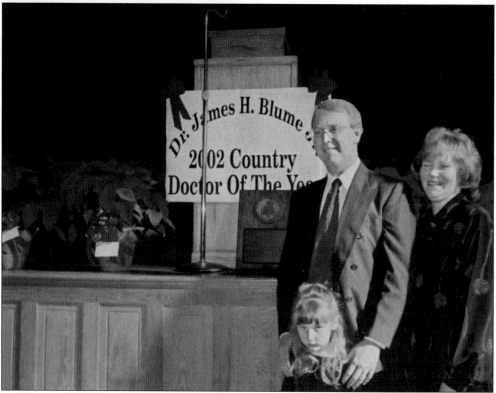

Six
GREENBRIER DISTRICT

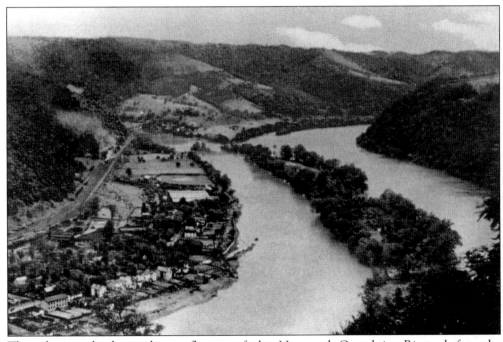

This photograph shows the confluence of the New and Greenbrier Rivers before the construction of the Bluestone Dam. This junction of the rivers occurs less than two miles upriver from downtown Hinton. Bellepoint is the residential section on the left on the photograph. A number of influential people have lived in Bellepoint, including Judge James Miller. (Photograph courtesy of the National Park Service.)

Hinton...Where the Greenbrier Meets the New
By V.E. Lilly

In the past and distant, when the earth took form,
When the land was torn by cosmic storm
As the seas ebbed slowly and the firmament rose
time began, life was born, and a new rivers flows
where the Greenbrier meets the New.

Eons and eons of rain, snow and sleet
created great valleys, where the ridges meet.
Where, from lofty peaks to hollows dark,
Came the sounds of the dove and the meadow lark
where the Greenbrier meets the New.

Then came the Shawnee and the brave Cherokee,
Before our fathers dared cross the great sea
But cross it they did, mid turmoil and strife,
where the Greenbrier meets the New.

Onward they struggled, toward the setting sun
'til finally they knew their journey was done.
They'd reached God's country, so calm and serene,
With lush river valleys and forests so green,
Where the Greenbrier meets the New.

They worked in the forest and started to cut
The tall chestnut trees, and fashioned their hut.
They cleared off the land, and planted their seed,
for now they had all that they'd ever need,
where the Greenbrier meets the New.

They hunted the deer, the fox and the bear,
produced all their food, and clothing to wear.
Then came the red warriors, in the dark of night,
But the mighty red men were forced to take flight
where the Greenbrier meets the New.

On westward the path, toward the frontier
but the hardy settler, the brave mountaineer,
decided this was the place he wanted to stay
and his blood flows through me to this very day
where the Greenbrier meets the New.

Then men with great vision brought the iron horse
and followed the rivers, their mouth to their source.
They carved out a village on a mountainside steep
and bridged the green valleys, the rivers so deep
where the Greenbrier meets the New.

They called the place Hinton, a town so fair
with fresh flowing waters and pure mountain air.
A courthouse they built there, midst a great lawn.
Great hopes and prosperity were starting to dawn
where the Greenbrier meets the New.

Though problems developed, as they usually will,
the village clung to the side of the hill.
And prosper it did, as our fathers had planned.
Soon a fine little town did, indeed, stand
where the Greenbrier meets the New.

She's sent sons and daughters to far distant shore
when she answered the call of her Country at war.
Think of them often, your respect they have earned.
Most made it home safely, some never returned
where the Greenbrier meets the New.

We still have old Temple Street and Ballengee too.
The old hotel, so forlorn, stands on the avenue.
And near where sits our Courthouse, covered in red,
Stands guard the lonely sentinel for our Civil War dead
where the Greenbrier meets the New.

Though the old town's still here, some say it's dying.
A few folks gave up, while other keep trying.
But the ancient New River, and the gentle Greenbrier
still keep flowing past us, still whet my desire
for where the Greenbrier meets the New.

(Courtesy of V.E. Lilly.)

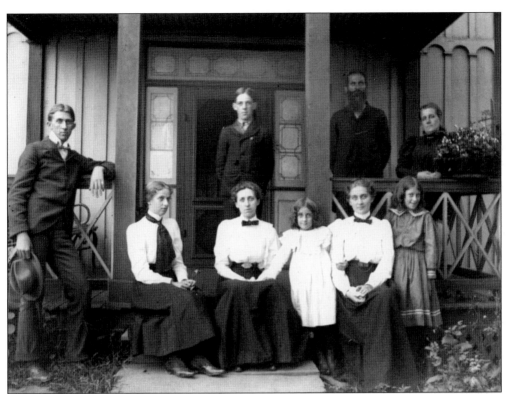

Silas and Mary Jane Hinton's home in Avis was the site of many social gatherings. This *c.* 1900 photograph shows Silas and Mary Jane (far right) on their porch with family members. (Photograph courtesy of National Park Service.)

Construction crews built the Ewart-Miller building—located across the street from the courthouse—in 1905. This building is primarily eclectic in style with a hint of Greek Revival in some of the detail. It has served principally as an office building, but at one time the third floor was used as a dance hall. A newspaper office once occupied the basement. (Photograph courtesy of the National Park Service.)

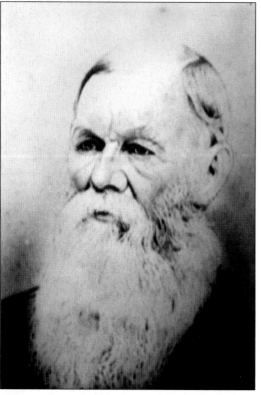

Avis Gwinn Hinton (1800–1901) was the second wife of John "Jack" Hinton, Sr. (1788–1858), a lawyer pictured below. Their children were Joe, William, Silas, and Gladys. Avis, the daughter of Moses Gwinn of Meadow Creek, owned the land where Avis is located and willed it to her children. The village of Avis, which is now part of Hinton, was named in her honor. John owned the land where Hinton is located. Most historians believe that Hinton was named for John, but some believe it was named for Evan, John's son by his first marriage. (Photograph courtesy of the National Park Service.)

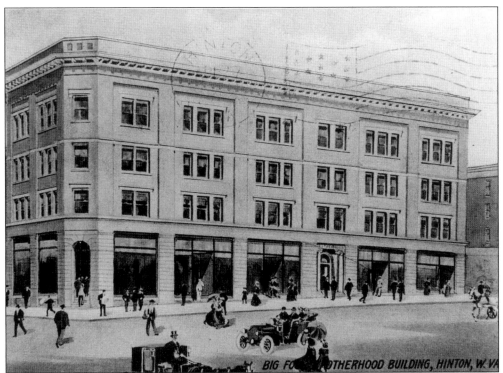

BIG FO[UR BR]OTHERHOOD BUILDING, HINTON, W.VA.

Four railroad brotherhoods (Orders of Railway Conductors, Trainmen, Locomotive Engineers, and Locomotive Firemen) built the Big Four Building, a four-story building of buff brick, in 1907. The building housed the Hinton Post Office, Hinton Hospital, various shops, offices, and apartments from 1907 to 1925. The sender of this postcard mailed it on April 27, 1908. The Big Four Drug Store has occupied the first floor since 1940. (Postcard courtesy of the National Park Service.)

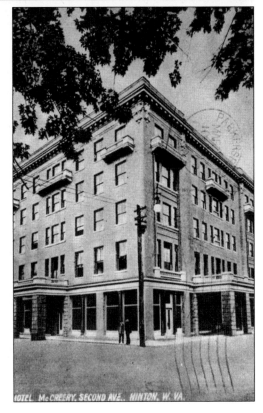

HOTEL McCREERY, SECOND AVE., HINTON, W. VA.

The McCreery Hotel, one of the finest hotels on the C&O Railway line, opened in 1907. Frank P. Milburn, who had previously worked on the courthouse and the Big Four building, was the architect. The modern hotel had baths, electric lights, electric elevators, and a telephone system. On a stone panel at the parapet, are the words "Hotel McCreery." The hotel, which cost over $100,000 to build, was, at the time, the most expensive building in the county. (Postcard courtesy of the National Park Service.)

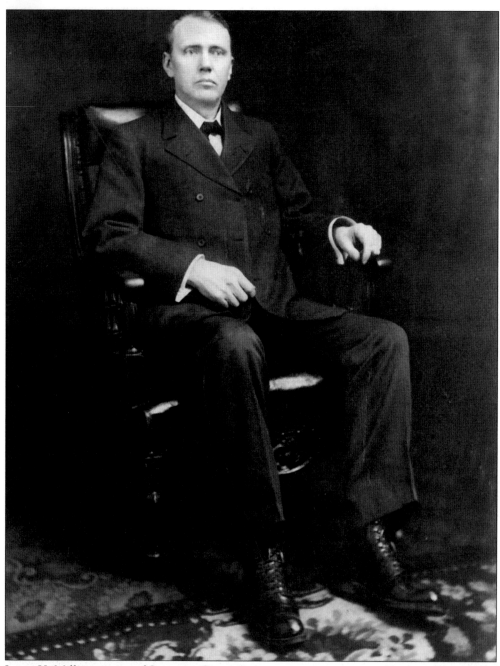

James H. Miller was one of Summers County's most prominent citizens. He served as judge of the Circuit Court of the Ninth West Virginia Circuit (a court composed of Summers, Raleigh, and Wyoming Counties). He was also involved in numerous business enterprises. He held the presidency of the Bank of Summers (four years), the Greenbrier Springs Company, and the Hinton Hardware Company. Miller was also a stockholder in the Ewart-Miller Company among others. Miller's book *The History of Summers County, From the Earliest Settlement to the Present Time* was published in 1908. This book describes people and events of the county in great detail. (Photograph from the James Miller book *The History of Summers County*.)

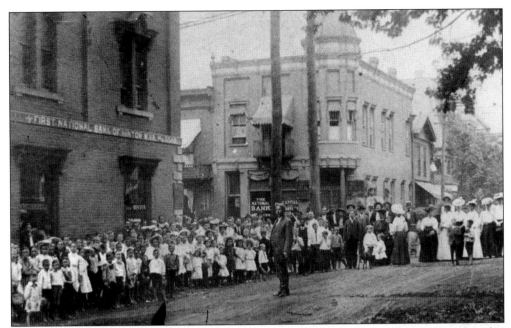

The Methodist Church Sunday School class is shown here gathering at Temple Street in this 1900s photograph. The First National Bank of Hinton is located on the left and across the street is the National Bank of Summers. Mud holes plagued this location until the street was paved. (Photograph courtesy of the National Park Service.)

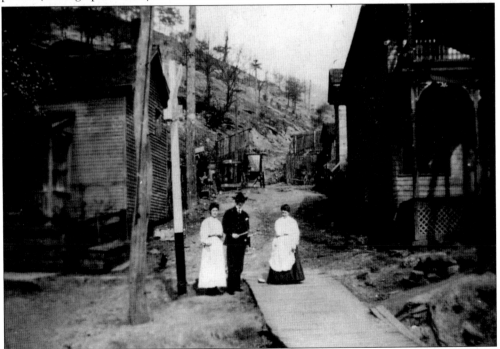

This photograph (c. 1918) shows Possum Hollow in the Avis area. Muddy streets were a frequent difficulty for pedestrians well into the 20th century. Notice the boardwalk constructed to help alleviate the problem. (Photograph courtesy of the National Park Service.)

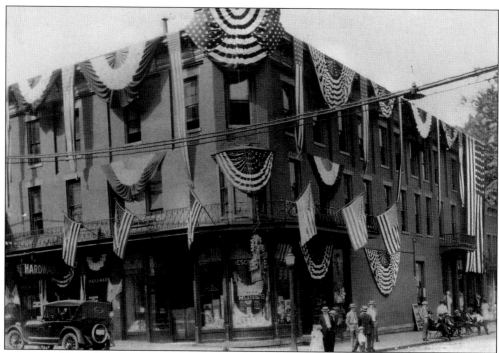

The Rose Drug Store was one of the leading commercial establishments in Hinton during the first half of the 20th century. Rose opened the drug store, located across the street from the Big Four building, in 1907. It closed in the 1940s. The Davis Department Store occupied the building until 1983 when a fire destroyed it. The above picture shows the drug store decked out in patriotic bunting for a July fourth celebration. (Courtesy of the National Park Service.)

Soda fountains were a popular feature of many drug stores in the early 1900s. Customers at the Rose Drug Store soda fountain could choose from a plentiful stock of drinks to quench their thirsts. (Photograph courtesy of the National Park Service.)

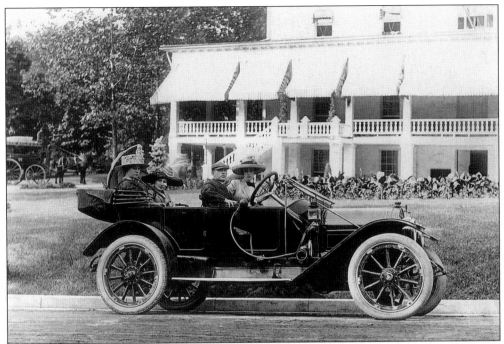

This 1916 photograph shows four prominent residents of Hinton seated in a car in front of the Greenbrier Hotel. In the front seat are Sven Rose, owner of Rose's Drug Store, and his wife Grace Miller Rose. In the back seat are Jean Miller and Daisy Miller Gooch. All three women were daughters of Judge James H. Miller. (Photograph courtesy of West Virginia State Archives, C-F-M House collection.)

Although only a few short segments of the New River are navigable, a favorite activity around 1900 was the boat trip between Hinton and Bull Falls near Warford. These passengers are enjoying a Sunday outing. (Photograph courtesy of the National Park Service.)

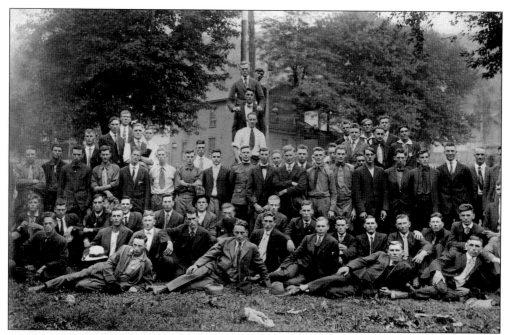

A common characteristic of many Summers Countians is their devotion to church and country. This 1917 photograph taken in Hinton shows these young men awaiting induction into military service during World War I. (Photograph courtesy of National Park Service.)

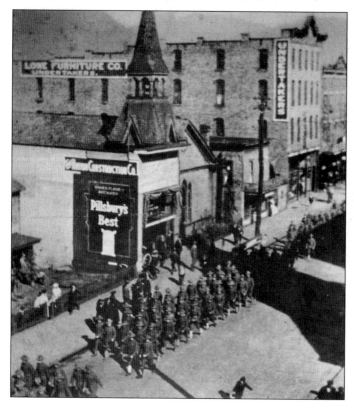

Inductees into the army march down Temple Street on their way to the railroad depot and World War I. (Photograph courtesy of Steve Trail.)

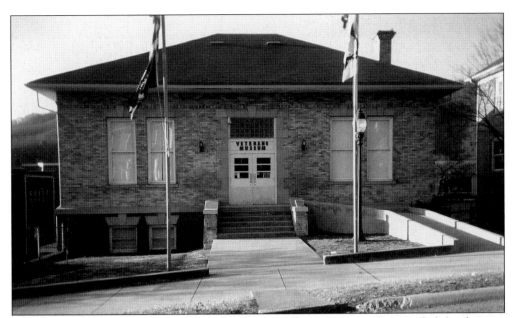

This building (c. 1913) was the Carnegie Library. Andrew Carnegie, the noted philanthropist, helped to finance the construction of the building. Later, it served as the library for Hinton High School. In May 1997, West Virginia governor Cecil Underwood assisted in the dedication of the building as the Veterans Memorial Museum of Southern West Virginia. This museum is one of the few such museums in West Virginia. (Photograph courtesy of Susan Robinson.)

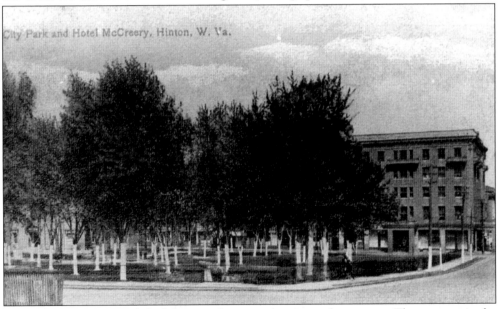

The old Hinton city park had four revolving steel gates at the corners. The gates were the entrances to the four paths that joined at the center where a fountain and pump house were located. The city park was a popular place for concerts and other public gatherings. In the background is the Hotel McCreery. In 1925, builders constructed the new Hinton post office along Ballengee Street where the city park had previously been located. (Photograph courtesy of the National Park Service.)

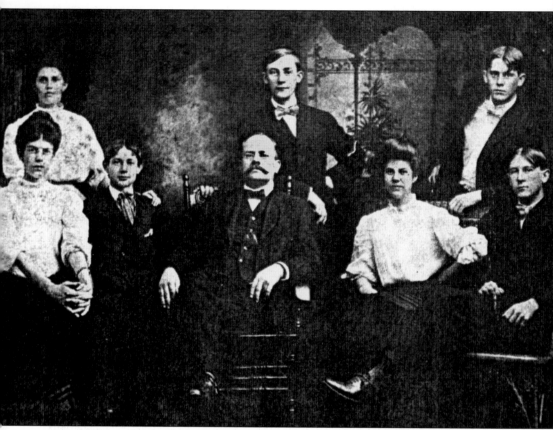

This picture (c. 1906) shows the sales staff of Parker's Department Store that, for many years, was located on the corner of Summers Street and Third Avenue. The staff are, from left to right, (front row) unidentified, Archie Saul, J.A. Parker, Josie Harbarger, and William Meador; (back row) Courtney Parker, Cleve Meador, and Lark M. Meador. Colonel Parker's career was one of rags to riches. Orphaned at just five years old, he came to Summers County in 1882 around the age of 20 with only assets of $3.50. He quickly got a job and, in two years, he was in business for himself. He soon had many business interests and quickly became one of the wealthiest men in the county. Some of his businesses include the following: Parker Opera House, the department store, two hotels, a saloon, and a grocery store. (Photograph courtesy of Will Meador.)

This photograph is a copy of the letter that Col. J.A. Parker wrote his former employee William Meador in 1912. In the letter, Colonel Parker offered to sell various businesses to Meador including his grocery store. Mr. Meador declined the offer and eventually opened up a grocery store on Third Avenue across the street from the Big Four Building. Colonel Parker passed away in 1913. (Letter courtesy of Will Meador.)

The Meador Grocery opened in 1913 and operated until 1947. In this photograph (c. 1920) taken in the interior of the store, William Meador is the gentleman on the far right. Mr. Meador's wife ran the store after his death. (Photograph courtesy of Will Meador.)

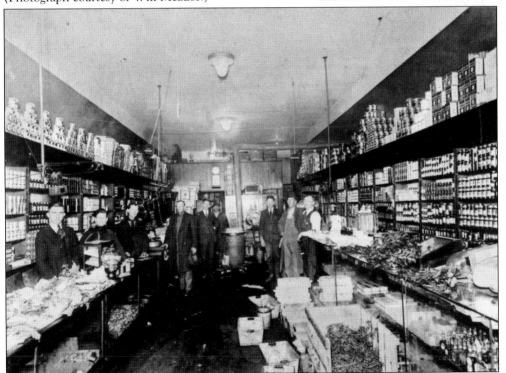

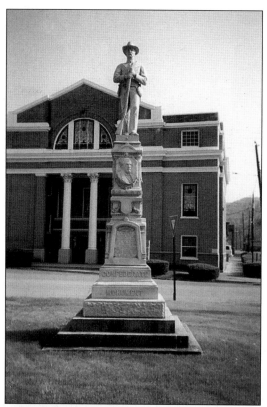

The Confederate Monument, with the Central Baptist Church in the background, was unveiled in Hinton in 1914. Highlighting the dedication day were a parade, speeches, and music. An estimated throng of 3,000 attended the ceremonies. All sides of the monument are inscribed with dedications. One inscription is remarkably modern and sensitive in tone. It reads, "Sacred to the memory of the noble women of the Confederacy who suffered more and lost as much with less glory than the Confederate soldier." (Photograph courtesy of Susan Robinson.)

This large 1960 crowd assembled in Hinton to listen to Eleanor Roosevelt and actor Lorne Green. The celebrities were supporting Hubert Humphrey for the Democratic Party nominee for president. (Photograph courtesy of the National Park Service.)

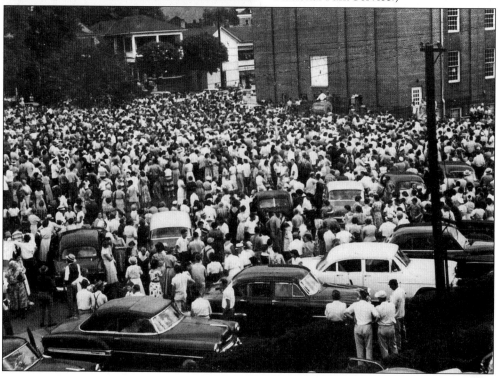

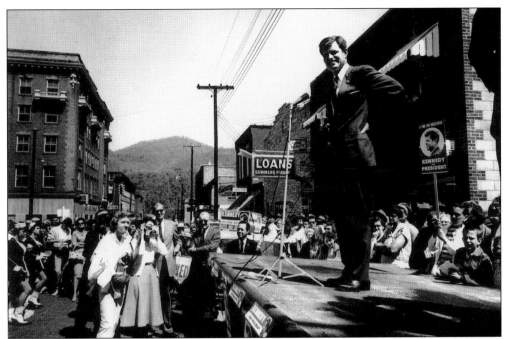

Hubert Humphrey did not win the Democratic Party nomination for president in 1960. John F. Kennedy was the victor. In this photograph, Teddy Kennedy campaigns on behalf of his brother for the presidency. (Photograph courtesy of Steve Trail.)

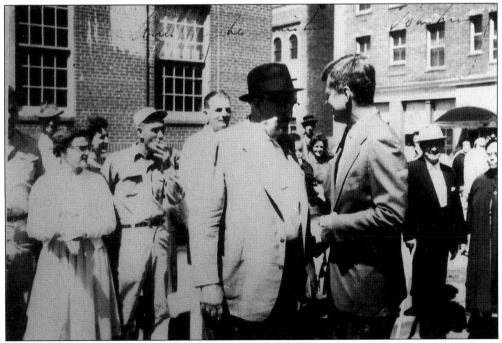

John F. Kennedy also campaigned on his own behalf in Summers County. This photograph shows Kennedy talking with Sheriff J.C. Dillon of Talcott in Hinton. (Dillon's Superette, Talcott Memorabilia Room, Hinton *Daily News* collection.)

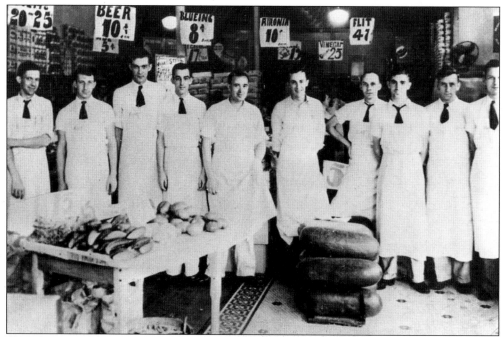

This photograph (c. 1930) shows the Kroger grocery store staff on Temple Street. They are (left to right) as follows: unidentified, Leonard "Todd" Lindsey, Archie Moonen, Harold Dressler, George Meador (manager), Johnny Hannah, ? Johnson (butcher), Ernest Dressler, Theodore Simpkins, and Chelsie Blankenship. (Photograph courtesy of the National Park Service.)

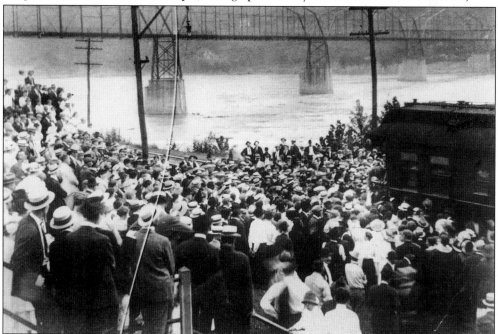

Many residents of Summers County have a keen interest in politics. This large crowd around the train is waiting to catch a glimpse of President Franklin D. Roosevelt. (Photograph courtesy of West Virginia State Archives, Steve Trail collection.)

Buzzy Hellems has operated a grocery store on Temple Avenue in Hinton for over 50 years. During the mid-1970s, he served as a state senator. He has a wealth of knowledge regarding local sports and politics. (Photograph courtesy of Tom Bailey.)

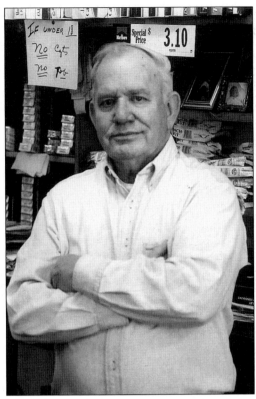

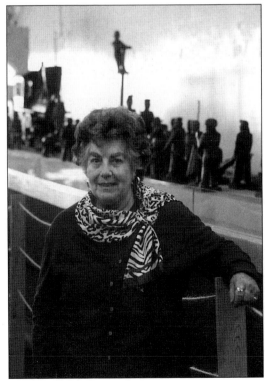

Dorothy Jean Boley worked for the C&O for over 40 years. Now she is a knowledgeable volunteer at the Hinton Railroad Museum and the Summers County Visitors Center. (Photograph courtesy of Tom Bailey.)

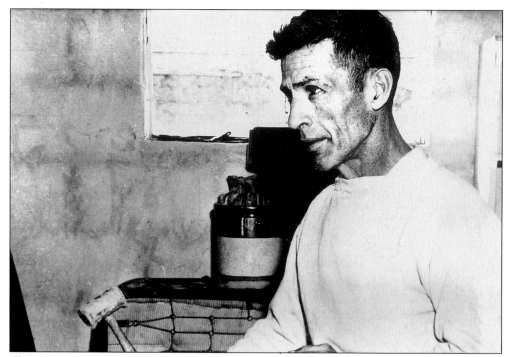

The Summers County Visitors Center and the Hinton Railroad Museum share a building next to St. Patrick's Church. An outstanding feature in the railroad museum is the John Henry woodcarving exhibit. Charlie Permelia (pictured above), a former railroader, created an impressive woodcarving display of John Henry and railroading in the early 1870s. The exhibit covers 96 feet and includes 93 human figures plus railroad equipment, horses, and mules. Permelia used 56 different woods native to West Virginia on the project that took him seven years to finish. The photograph below shows a small section of the John Henry display. (Photographs courtesy of Tom Bailey.)

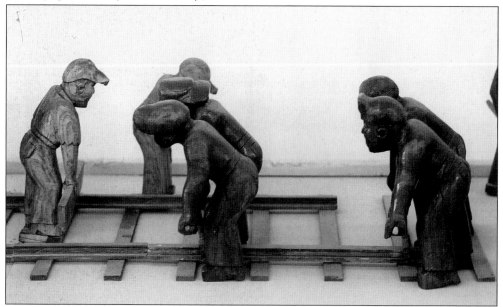

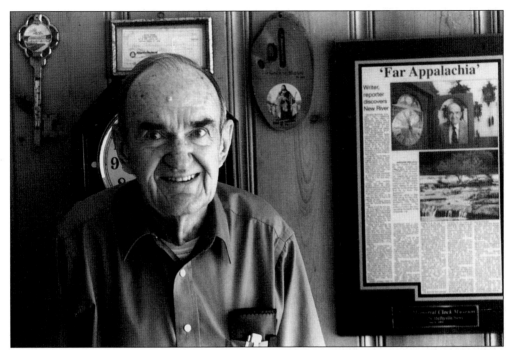

Charles Wood stands next to a newspaper account of his inclusion in Noah Adams's book *Far Appalachia*. Mr. Wood has had many interesting careers. In the 1930s, he was a musician. In the early 1940s, he managed a farm for Indiana Senator Frederick Van Nuys. Later, he moved to Florida and served as a minister for over 40 years. Currently he is a clockmaker and operates the Wood Clock Museum on Temple Street in Hinton. (Photograph courtesy of Tom Bailey.)

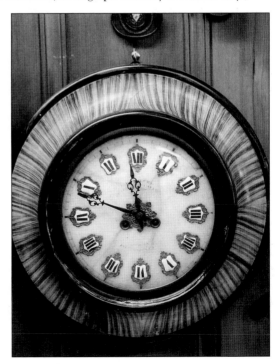

There are 600 clocks in the Wood Clock Museum in Hinton. The oldest and most valuable is the clock shown in this photograph. Clockmakers created this clock in Paris, France in 1545. The clock's face is made of bone while the numbers are porcelain. The wood came from Africa. (Photograph courtesy of Tom Bailey.)

James Leslie served as Hinton's mayor for a longer than anyone else in Hinton history—18 years. Major developments during his administration (1983–2001) include the following: designation of downtown Hinton on the National Register of Historic Places, establishment of a railroad museum, creation of a town park, and the receipt of a grant for restoration of the railroad depot. (Photograph courtesy of James Leslie.)

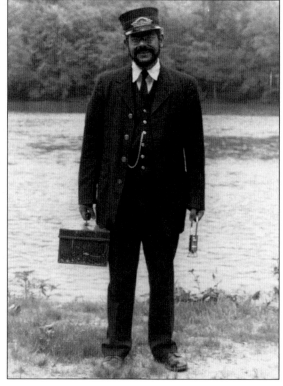

For two weekends each October, Hinton relives its rich railroad tradition at the Hinton Railroad Days. The festivities include music, entertainment, food, and vendors of many different products including railroad artifacts. This photograph shows Jim Costa attired in a railroad uniform. Costa frequently sings and plays stringed instruments at the festival. (Photograph courtesy of the National Park Service.)

Seven
Green Sulphur District

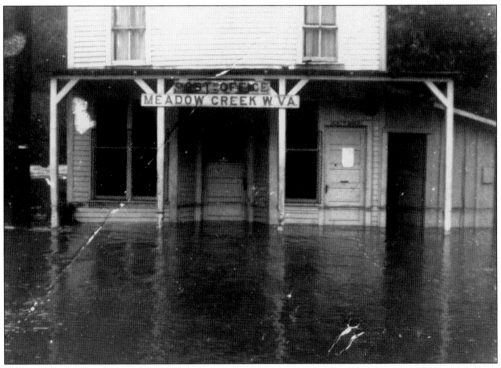

This photograph shows the result of the flood of 1940 on the Meadow Creek Post Office. Meadow Creek is one of the older communities in the county. The King of England gave a land grant to the Gwinn family that included the Meadow Creek Valley. The Post Office Department established a post office here in 1873 and, soon after, the C&O Railway built a terminal at Meadow Creek. In the early 1900s, the Sewell Valley Railroad (later the NF&G Railroad) was created. That railroad served Meadow Creek and connected with the C&O Railway mainline. (Photograph courtesy of the National Park Service.)

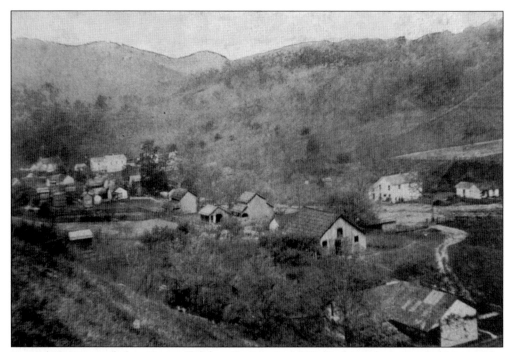

Samuel Gwinn settled at Green Sulphur Springs in 1798. Early settlers regarded him as the "Father of Green Sulphur Springs." This photograph shows a view of the village around 1900. Bottling spring water was a flourishing business by 1848. Brick mason Silas Taylor built Ephraim Gwinn a house with walls 13 inches thick in 1852. In 1871, when Summers County was formed, that house was one of only two in the district constructed of brick. In the Green Sulphur Springs area, there are several archaeological sites. (Photograph courtesy of Charlie and Janis Boyd.)

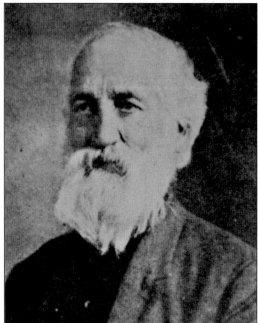

Harrison Gwinn was highly esteemed by his peers and was active in a number of endeavors. He served as Green Sulphur Springs postmaster for 43 years, and he was president and on the Board of Directors of the Bank of Summers. During his tenure as bank president, the institution prospered. He also was engaged in the lumber business and served two four-year terms as sheriff. (Photograph from the James Miller book *History of Summers County*.)

Mr. James E. Jamison built this Green Sulphur Springs store in 1875. He carved the scroll work with small hand tools. The structure is the oldest business building in continuous use in the county. The building has always housed a store and for many years it also served as a post office. The postal authorities discontinued the post office in 1990 after more than 130 years of service. Located next to the store is Lick Creek Baptist Church, which was established in 1832. (Photograph courtesy of Charlie and Janis Boyd.)

Charlie Boyd, a staff sergeant and a highly decorated soldier in World War II, stands by a display case containing his medals. His bronze star is in the upper left corner of the case. He operated the Green Sulphur Springs store and post office for 34 years. *Goldenseal*, a magazine of West Virginia traditional life, featured Boyd in their Summer 1986 issue. (Photograph courtesy of Susan Robinson.)

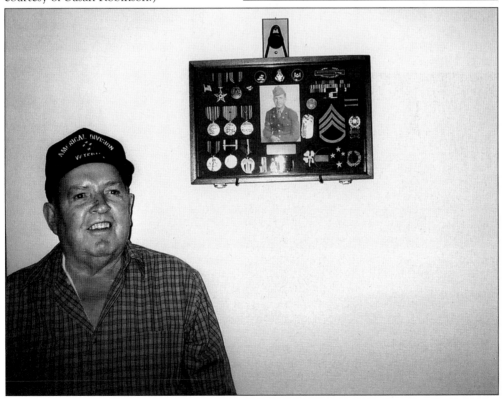

William Richmond, pictured here, emigrated from England to the United States. During the War of 1812 with England, he fought on the side of the Americans. After the War, he settled in what is now Raleigh County along the New River. William is the patriarch of the Richmond family throughout the region. He and youngest son Samuel (1801–1863) started a ferry (c. 1830–1840) across the New River between Raleigh and Summers Counties. That ferry operated for about 160 years. The fare for a crossing was 10¢. During the Civil War, rebel sympathizers ambushed Samuel, a Union supporter, while he was operating the ferry. He was a brave and powerful man and completed his journey across the river before he died. One of Samuel's sons, John A. Richmond, settled in Summers County. (Photograph courtesy of Bill Richmond.)

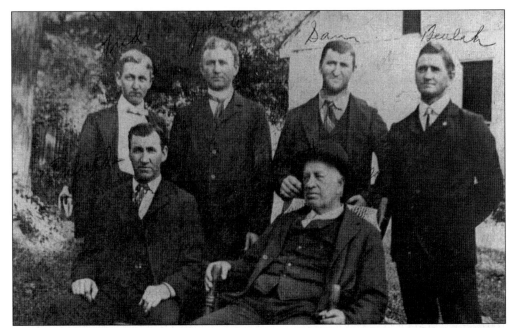

John A. Richmond and five of his sons are shown in this photograph (c. 1900). Seated left to right are Enfield and John A. Standing in the photograph are Fred, John W., Sam, and Beulah (B.B.). John A. was a merchant and postmaster for over 40 years. After his death, his wife Permelia also served as postmaster. Fred and B.B. were doctors; Sam worked as a justice of the peace; and Enfield was a railroad conductor. John W. was a postmaster and merchant at Sandstone like his father. (Photograph courtesy of Remona McMillon.)

This photograph, taken around 1900, shows some members of the Richmond family with relatives relaxing at Sandstone Falls. Leona Richmond Miller is the first lady in the front row. In the second row, Fred Richmond is the gentleman with a dark hat and bowtie and B.B. has his arms crossed at the far right end of the row. Ida Richmond Callahan, wearing a black hat, is in the last row. (Photograph courtesy of Remona McMillon.)

91

ALBERT S. BURLESON

POSTMASTER GENERAL OF THE UNITED STATES OF AMERICA

TO ALL TO WHOM THESE PRESENTS SHALL COME, GREETING:

KNOW YE, *That, reposing special trust and confidence in the intelligence, diligence and discretion of* John W. Richmond *I have appointed and do commission him Postmaster at* Sandstone *in the County of* Summers *State of* West Virginia *, and do authorize and empower him to execute and fulfill the duties of that office according to the laws of the United States and the regulations of the Post Office Department, and to have and to hold the said office with all the rights and emoluments thereunto legally appertaining, during the pleasure of the Postmaster General of the United States.*

IN TESTIMONY WHEREOF *I have hereunto set my hand, and caused the seal of the Post Office Department to be affixed, at the city of Washington, this* eighteenth *day of* May *, in the year of our Lord one thousand nine hundred and* fifteen *, and of the Independence of the United States of America the one hundred and* thirty-nine.

A. S. Burleson
Postmaster General

This document from the Postmaster General shows the appointment of John W. Richmond as postmaster at Sandstone in May of 1915. (Photograph courtesy of Remona McMillon.)

Several people who were concerned about the welfare of birds established the Three Rivers Avian Center in Brooks. The Center is an animal shelter for injured and endangered wild birds. A major aspect of the center's educational programs is directed to schoolchildren. The center's education presentation discusses various aspects of raptors including their role in the environment and the everyday hazards they face. The photograph shows Twister, a barn owl, a resident at the Three Rivers Avian Center. (Photograph courtesy of Randy Petry.)

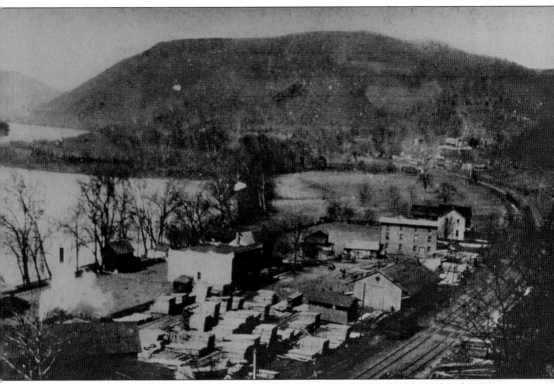

This panoramic view shows how Sandstone looked in the 1920s. In the foreground is the town lumberyard. The large building adjacent to the lumberyard and close to the New River was the O.T. Honaker store. The large three-story building close to the railroad tracks was the John W. Richmond store that housed the post office. In the middle of the photograph, between the railroad and the New River, was the Sandstone quarry. During the construction of the Washington Monument, each state furnished a stone to be placed in the monument. In 1884, the stone from West Virginia was placed in the monument. It came from the quarry at Sandstone. The Richmond family settled in this area in the early 1800s. On the Raleigh County side of the New River, the Post Office Department established the Richmond Falls post office in 1856. With the formation of Summers County in 1871, the postal authorities approved the move of the post office across the river and named it New Richmond. In 1915, the name of the station and post office was changed to Sandstone to avoid confusion with another C&O station with the same name. (Photograph courtesy of Remona McMillon.)

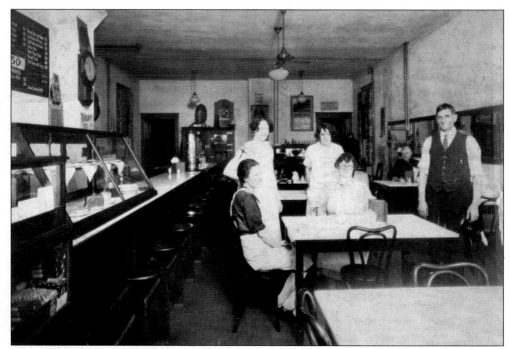

O.T. Honaker was an enterprising and industrious individual. He was born in 1868. When he was 16, he walked over the mountain from Clayton to Sandstone. Honaker started working in a sawmill. Soon he, his brother Calvin, and a Mr. Graham established a planing mill. In addition, he and his wife operated a large general store at Sandstone. During his career, Honaker also managed the lunchroom at the Hinton depot, as shown in this photograph. (Photograph courtesy of Janis Boyd.)

Jess Honaker, the son of O.T. Honaker, and his wife, Mary, were also industrious citizens of Sandstone. At various times, they operated a sawmill, a general store and filling station, a garage, a school bus service, and a taxi and a bus service between Hinton and Rainelle in Greenbrier County. Pictured are Jess and his son Dickie. (Photograph courtesy of Janis Boyd.)

94

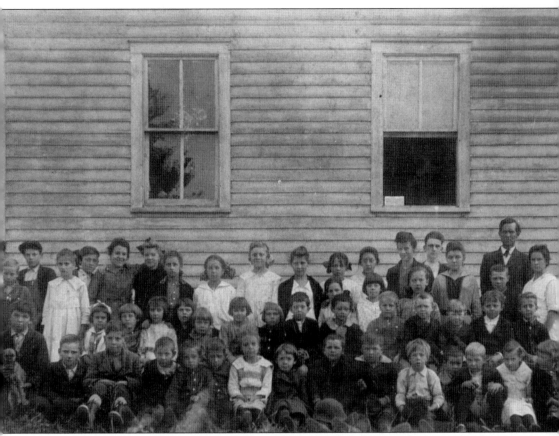

Students of the Sandstone Elementary School assembled for this photograph in 1917. Married names listed below are in parentheses. Pictured from left to right are the following: (first row) Frank Burdette (with dog), Ray Burnette, ? Kincaid, Sam Henry Fox, Lawrence Lusher, Lester Lusher, Susan Ames (Lively), Edith Eckle (Coffman), ? Morrison, ? Morrison, Elva Ayers, unidentified, John Burdette, Edith Cantrell (Knighton), and Mabel Gillan (Lewis); (second row) ? Kincaid, Margaret Richmond (Honaker), Vivian Gillian, Eula Gillian (Kibler), Evelyn Gillian (Morris), Mildred Burnette, Lena Lusher, Glennis Ames, Ralph Gillian, George Alvin Kibler, Charles "Dutch" Kibler, James Bragg, and Kyle "Beau" Gillian; (third row) Dewey Cales, Betty Cooper, two unidentified, Ursa Burdette, two unidentified, Leora Burdette (Hatrah), Jake Kibler, and Ina Honaker (Keaton); (fourth row) Stewart Lee "Happy Jack" Richmond, John Cantrell, Jess Gillian, Alice Kincaid (Crowe), Edna Eckle (King), Amy Fox, Berma Honaker (Keaton), Norma Cooper (Bennett), Bessie Gillian, ? Taylor, Leona Holland, Zena Rodes (Keaton), Lesley Withrow, and teacher Charley Rodes. (Photograph courtesy of Janis Boyd.)

Estimated Escape Route of Mary Draper Ingles

In July 1755, Shawnees attacked the settlement of Draper's Meadows near present-day Blacksburg, Virginia. They captured Mary Draper Ingles. After a month, the party reached an Indian village near present day Cincinnati, Ohio. There Mary met an elderly Dutch woman (her name is unknown) who had been captured in a separate raid. Later the Shawnees took the two women to the Big Bone Lick in Kentucky to make salt. Mary urged the other woman to join her in a daring escape. The journey home took 42 days and covered over 500 miles. The women followed the Kanawha and New Rivers, including a portion in Summers County, as depicted on the map. The courage and determination of Mary Draper Ingles is a testament to the challenges, hardships, and difficulties that pioneers were confronted with in forging our nation. The experiences of Mary Draper Ingles and the Dutch woman were noteworthy for two other reasons. On their original journey, they traveled farther west than any other women of European descent. In addition, they were the first non-Indian women to make salt west of the Allegheny Mountains. (Map courtesy of Jamie Wykle.)

Eight
JUMPING BRANCH DISTRICT

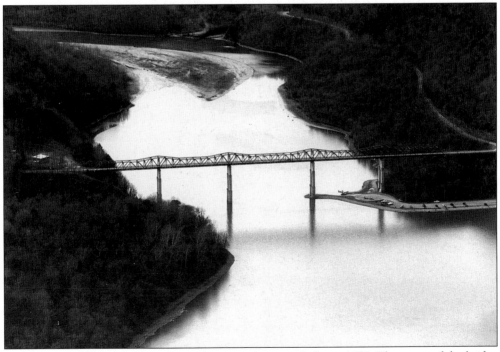

Construction crews built the Lilly Bridge over Bluestone Lake in 1950. The name of the bridge honors the village of Lilly that was three miles from the bridge at the junction of the Little Bluestone and Bluestone Rivers. The Lilly and Meador families settled in the area *c.* 1798. The construction of the Bluestone Dam that created Bluestone Lake forced abandonment of the village. Before the construction of the dam, Lilly had been a thriving community with a church, school, post office, general store, and gristmill. (Photograph courtesy of Tom Bailey.)

Robert "Miller Bob" Lilly built this small gristmill on the Little Bluestone River in 1869. Ownership of the mill passed on to Josiah Cooper, and then it was known as Cooper's Mill. It served the families along the Bluestone and Little Bluestone Rivers from 1869 to 1950. Since most of these families were engaged in subsistence farming, they needed their corn, wheat, and buckwheat ground in order to make flour and meal. By 1950, most of the people in the area had left due to the construction of the Bluestone Dam. (Photograph courtesy of Dr. Jack Wills.)

Joe "Little Joe" Meador, author, was the proclaimed "Poet of Summers County." The Meador family was a pioneer family in Summers County. His great-great-grandfather Meador came to the United States from Scotland and named each of his seven sons with a name starting with a "J." The family and their descendants became known as the seven-J family. Joe's great-grandfather Josiah Meador founded the Bluestone Baptist Church, the oldest church in the county. (Photograph from the James Miller book *History of Summers County*.)

Josiah Meador established the Bluestone Baptist Church in his house on the Little Bluestone River in 1798. In time, more of the congregation came from the village of Jumping Branch area, and the church was moved there. During the Civil War, Federal troops burned the church. Members were resilient and rebuilt the church. For many years, the church has been the center of community activity with revivals, children's programs, singing school, and Sunday school picnics. (Photograph courtesy of Susan Robinson.)

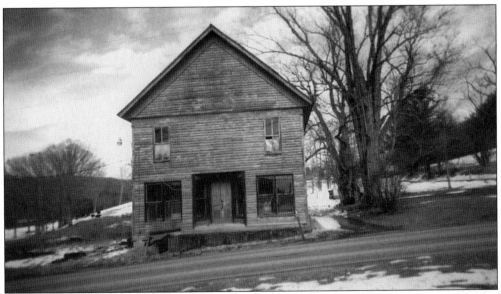

Deeds Hall served the community of Jumping Branch for many years. The Jumping Branch post office and a general store were located here. The second floor was a meeting place for lodge members. When the Bluestone Baptist Church burned in 1913, the congregation met at Deeds Hall until workers repaired the church. It is located across the street from the church. (Photograph courtesy of Susan Robinson.)

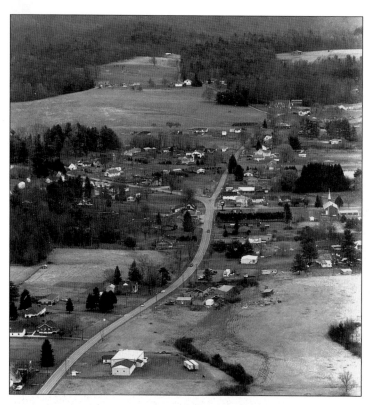

This aerial photograph shows the village of Jumping Branch. The origin of the name comes from the fact that, before there were any bridges in the area, riders would jump their horses over the branch. Jumping Branch has one of the oldest active post offices in the county. Postal authorities established a post office here in 1853. The village sustained considerable damage when Federal troops burned it during the Civil War. (Photograph courtesy of Tom Bailey.)

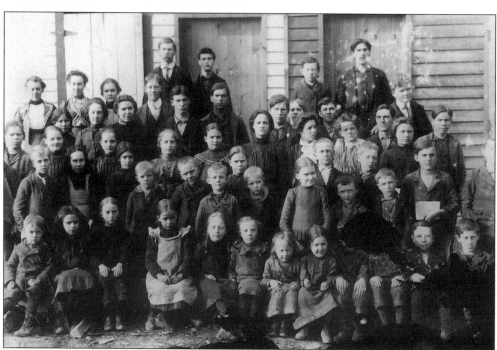

These students attended the Jumping Branch School around 1900. In the second row, Stella Mann is the first girl from the right. (Photograph courtesy of Charles Wood.)

The Neely family was among the early settlers of Summers County. They resided primarily in the Jumping Branch and Pipestem Districts. Levi M. Neely Sr., pictured here, was a miller and deputy sheriff from 1897 to 1900. The citizens held him in high regard for his honesty and kindness. (Photograph from the James Miller book *History of Summers County*.)

Residents of the community founded the Bluestone View Primitive Baptist Church in 1896. The original church made of log construction was located nearby. According to local tradition, members of this congregation witnessed a remarkable event. Several men were fighting a fire on church property. Without a cloud in the sky, "Uncle" Jimmy Adkins prayed for rain. Within 15 minutes, a small cloud appeared and it rained, saving the property from any further damage. (Photograph courtesy of Susan Robinson.)

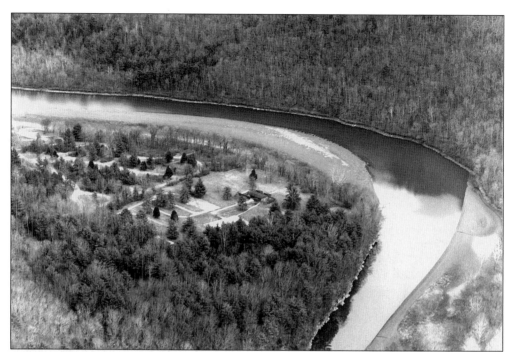

Established in the early 1950s, beautiful Bluestone State Park covers 2,100 acres of rugged mountainous terrain. The park is adjacent to Bluestone Lake, the third-largest lake in the state. Fishing and boating activities are very popular with visitors to Bluestone Lake. This photograph shows a portion of the park and the Bluestone River. (Photograph courtesy of Tom Bailey.)

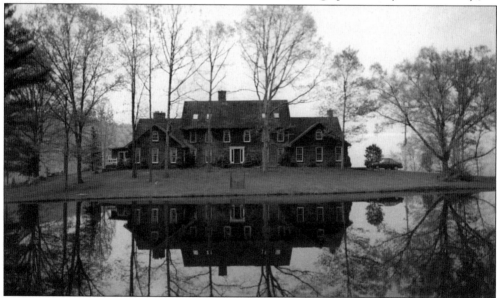

John and Betty Ellison Elwood's Foxwood Bed and Breakfast is located about 10 miles from the village of Jumping Branch. Betty is a descendant of early settlers in the area. She is the great-great-great granddaughter of Jonathan Ellison, who purchased 1,577 acres in the region in 1867. Foxwood is an elegant but comfortable bed and breakfast. Its secluded mountain setting promotes a feeling of serenity and peacefulness. (Photograph courtesy of Susan Robinson.)

Nine
PIPESTEM DISTRICT

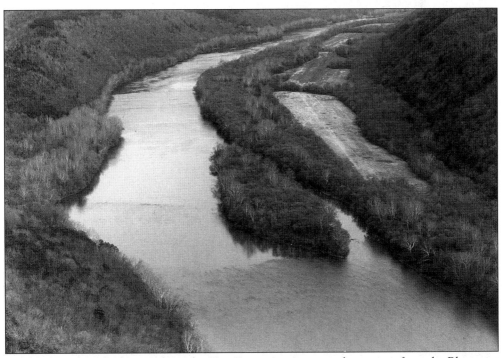

Crumps Bottom, which runs along the New River, starts nine miles upriver from the Bluestone Dam. It is about six miles in length and is one of the few extensive level pieces of land in Summers County as well as in southern West Virginia. The land was periodically occupied by Indians thousands of years ago. The first identifiable European descendant who lived in Summers County, Andrew Culbertson, settled here in 1753. Before the construction of the Bluestone Dam, Crumps Bottom was one of the prime grain producing areas in the county. (Photograph courtesy of Tom Bailey.)

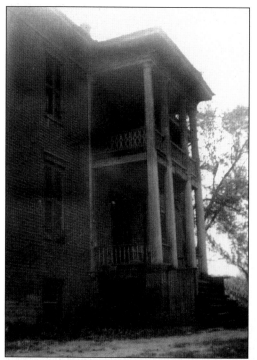

Maj. William Crump built Crumps Mansion with slave labor about 1850. The building had 22 rooms and was furnished with beautiful antique furniture, imported carpets, and glass candelabras. The mansion was the site of many elegant parties. The property also included an icehouse, smokehouse, blacksmith shop, apple orchard, granary, barns, and slave quarters. Crump had 126 slaves and was one of the few slaveholders in Summers County before the Civil War. Crumps Bottom was also the site of one of the first post offices in the county. The Post Office Department established a post office in 1849. Postal authorities discontinued the post office in 1948. For many years, the Crumps Bottom post office was located on the first floor of Crumps Mansion. Ultimately, the building fell into disrepair and was demolished around 1950. (Photograph courtesy of Steve Trail.)

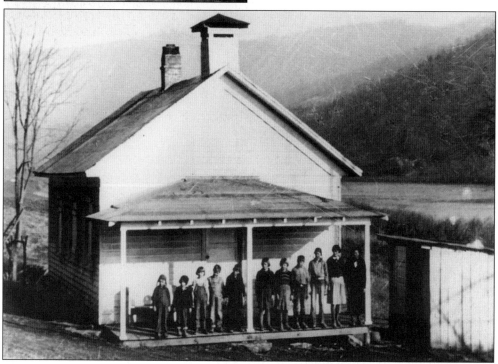

This 1944 photograph shows teacher Charles Bradberry and his class at Barker School at Crumps Bottom. With the construction of the Bluestone Dam, the community of Crumps Bottom was abandoned in the late 1940s. (Photograph courtesy of West Virginia State Archives, Steve Trail Collection.)

Charles Clark drilled for salt at a location that became known as Mercer Salt Works in 1849. Salt production continued from 1850 to 1861. During the Civil War, Union forces burned it down. In 1862, Clark and William Crump rebuilt the salt works. In 1866, the operators shut down the salt works permanently because the business had ceased to be profitable. During his career, Clark also served as postmaster at the Mercer Salt Works and Tophet post offices. (Photograph from the James Miller book *History of Summers County*.)

Walter P. Bowling was the first postmaster at Tophet. The Post Office Department established the Tophet post office in 1889. It was discontinued in 1948. The way Tophet acquired its name was unusual. The local community was known as Hilltop, but on its application to become a post office, the postal authorities mistook the "i" for an "e." They would not establish a post office with the name of "Helltop." They substituted the name "Tophet", a Biblical word for an unpleasant place. (Photograph from the James Miller book *History of Summers County*.)

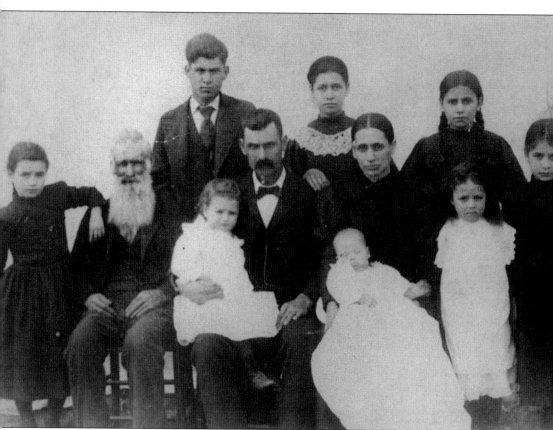

One of the first, most prominent, and largest families who settled in Pipestem District was the Farley family. Thomas Farley came to the Crumps Bottom area shortly after Andrew Culbertson (c. 1755). He built a fort in the Crumps Bottom area around 1775. Drewry Farley (1760–1851) served in the Revolutionary War with Daniel Boone. He settled in the Pipestem District before 1800. Drewry gave Pipestem its name. He named the area for the plant *spirea alba* that was common in the vicinity. Indian and early settlers used the hollow stems for their pipes. Shown here is Joel Farley, a Confederate soldier during the Civil War, and other family members. Joel is the gentleman of the front row with the white beard. Chapman Farley, with a baby, is seated next to Joel. Next to Chapman is Juda Farley who also is holding a baby. Wetzel Farley is on the back row. (Courtesy of Bob Farley.)

Gordon Jordan (1812–1886) was a prominent citizen of Pipestem District. He and his brother Thomas donated the land for Jordan's Chapel. Jordan was a Confederate soldier, farmer, builder, and a justice of the peace. His house was a stopover for several judges and lawyers during their travels. The Post Office Department established in 1870 a post office in the area named Jordan's Chapel. Jordan served as its first postmaster. The name of the post office was changed to Pipestem in 1880. (Photograph from the James Miller book *History of Summers County*.)

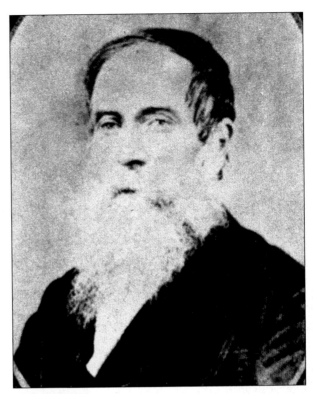

Rev. Robert Sheffey (1820–1902), a pioneer itinerant Methodist minister, regularly stayed with his good friend Gordon Jordan when he would come to preach at Jordan's Chapel. Author Jess Carr, who wrote a Sheffey biography, termed him "The Saint of the Wilderness." He often preached in Summers and Mercer Counties, West Virginia. Sheffey's prayers were eloquent and often highly effective. (Drawing courtesy of Lois Carr.)

Builders constructed Jordan's Chapel in 1852. The chapel's remarkably good condition is a tribute to the fine workmanship of its construction. It is one of the oldest structures in Summers County and the oldest frame church in the county. (The earlier ones were made of logs.) Nestled in the woods, the church projects a "quiet elegance." Jordan's Chapel is on the National Register of Historic Places. It is also a Historic Site of the Methodist Church. (Photograph courtesy of Susan Robinson.)

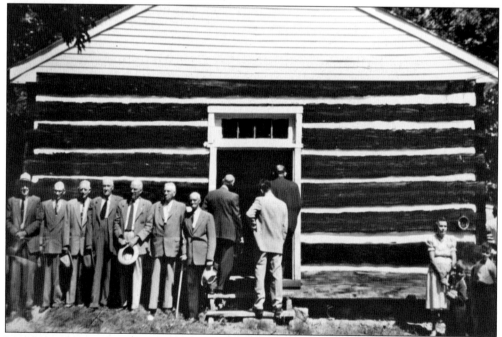

Members of the Farley family were instrumental in the establishment of the Rocky Mount Church in 1869. The prospective members held the organizational meeting at Jordan's Chapel. They chose the name Rocky Mount because members of the Farley family came from Rocky Mount, Virginia. This photograph (c. 1915) shows (from left to right) the following church members: John Richmond, Henry Spangler, Ward Trail, Everett Cook, Cowboy Switzer, Alonzo Hopkins, and Tom Weatherford. (Photograph courtesy of Bob Farley.)

The community of True got its name in an interesting fashion. In 1882, residents around the mouths of the Bluestone River and Pipestem Creek wanted a post office. According to local legend, Larkin Meador, filed an application for a post office. At the end of the petition he wrote "all of the above is true." The postal authorities approved the application and named the new post office "True." (Photograph courtesy of the West Virginia State Archives.)

This photograph (c. 1920) shows a group of well-dressed young people in front of the True general store and post office. In the 1940s, the post office was moved three miles to Tallery Mountain due to the construction of the Bluestone Dam. This "True" is a picturesque widely-dispersed farming village. In recent years, the post office has been inactive. (Photograph courtesy of Steve Trail.)

This photograph (*c.* 1914) shows Herbert Bowling (left) and Earl Meadows riding a track bike on a narrow-gauge railroad that ran along the Bluestone River. At that time, logging was a principal occupation in the area. (Photograph courtesy of Pipestem State Park.)

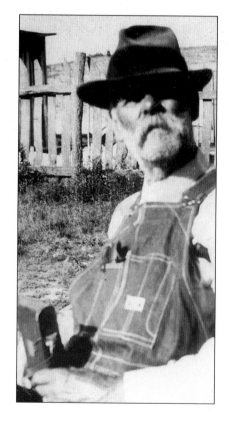

This gentleman is "River Jim" Cox. In the 1920s he ran a store on the Bluestone River where the Mountain Creek Lodge of Pipestem State Park is presently located. (Photograph courtesy of Pipestem State Park.)

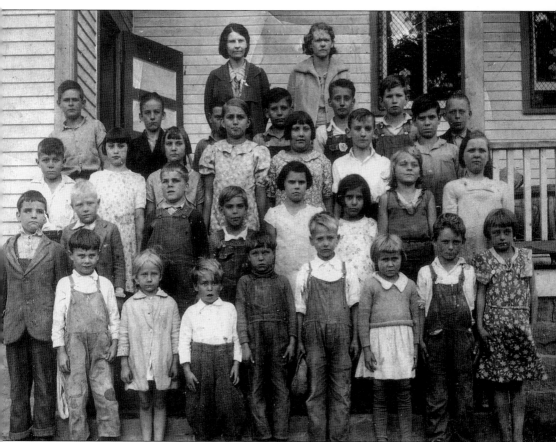

Established in 1923, the Pipestem Elementary School served the community for about 70 years. This photograph shows the students of 1933. Note the prominence of the Albert, Ellison, Farley, Neely and St. Clair surnames. Married names are in parentheses. Pictured from left to right are the following: (first row) two unidentified, Iris Albert, Bobby Neely, Fred Farley, Howard Albert, Joann Neely, Junior Neely, and Virginia St. Clair (Petrey); (second row) Jay Albert, Hunter Green Farley, Jack Farley, Willa Mae Farley, Hattie May Farley (Lowe), Hattie St. Clair (Law), and Alice Albert; (third row) Harold Reed, Genevieve Neely (McNeer), Kathleen Ellison (Hight), Ruby Albert, Kenneth Farley, and Billy Farley; (fourth row) Billy Joynes, Ernest St. Clair, James Neely, Fred Albert, Ray Albert, Oswell Ellison, and Forest St. Clair; (fifth row) teachers Blanche Farley (Ellison) and Edna (Farley). (Photograph courtesy of Pipestem State Park.)

Falious Harris built this cabin (c. 1900) for himself and his wife, Evie. They lived in the community of True. They made a living by selling produce, fruit, eggs, butter, homemade cottage cheese, and damson plum preserves. Their granddaughter Edith Boyer and her husband, Dan, donated the cabin, and it was relocated in Pipestem State Park in 1996. This modest cabin serves as a reminder to the harsh and difficult life that many early hardy residents of Summers County encountered. (Photograph courtesy of Susan Robinson.)

This photograph (c. 1930) shows a gathering of members of the Farley and Neely families. Shown from left to right are (front row) Cecil Farley, Elbert Mann, Donald Neely, Opal Montgomery, Vivien Farley, and Robert Farley; (middle row) Russell Keadle, Frank Mann, Lester Neely, Willie Montgomery, and W.W. Farley Sr.; (back row) Hubert Farley, Ollie Farley Keadle, Emmy Farley Mann, Lilly Farley Neely, Laura Vest Farley, and Pearl Farley Neely. (Photograph courtesy of Bob Farley.)

Don West—poet, preacher, scholar, farmer, teacher, union organizer and civil rights activist—was a multitalented individual. One of his most noteworthy endeavors was his establishment of the Appalachian South Folklife Center at Pipestem in 1965. The Center offers free summer camps for disadvantaged youth, community outreach services, and conference facilities including a library. The Center sponsors an annual festival with mountain music performers. In the past, musicians such as Merle Travis and Pete Seeger have performed at the festival. (Photograph courtesy of the Appalachian South Folklife Center.)

John Faulconer (1903–1981), an outstanding athlete as a youth, served as the editor for the *Hinton Daily News* for many years. He constantly strove to make Summers County a better place to live. Due to his frequent progressive editorials and endeavors, many people regarded him as "The Patron Saint of Summers County." One of his premier projects was the establishment of Pipestem State Park. For his efforts, locals dubbed him "Father of Pipestem State Park." (Photograph courtesy of James R. Pettry.)

Many people regard Pipestem State Park as the crown jewel among West Virginia's excellent state parks. The park offers lodging at McKeever Lodge at the edge of the impressive Bluestone River Gorge as well as at the secluded Mountain Creek Lodge next to the Bluestone River. Cabins and camping facilities are also available. Pipestem State Park provides its guests with a wide range of activities including two golf courses, horseback riding, swimming, tennis, archery, and miniature golf. Other features include the nature center, craft shops, and an outdoor amphitheater. (Photograph courtesy of Tom Bailey.)

This barn was one of two dozen buildings that Carlean Keaton had on his farm at the River Ridge section of Pipestem district. During his adult years Carlean farmed, logged, and operated a sawmill. Carlean was thrifty and lived a simple but happy life. His philosophy of financial management was to not buy anything unless it was absolutely necessary. (Photograph courtesy of Steve Trail.)

Ten

TALCOTT DISTRICT

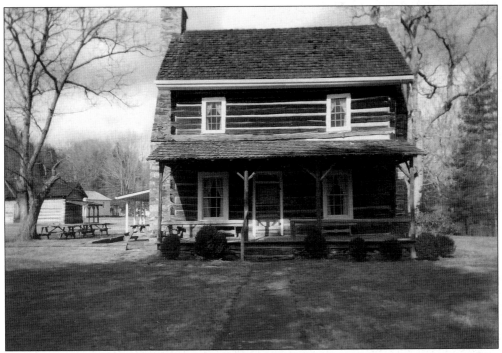

Col. James Graham constructed this house in the early 1770s. The Graham House is one of the oldest and most historic buildings in the State of West Virginia. On the National Register of Historic Places, the Graham House was an unusually large, stout and fine house for its location and time. In the spring of 1777, Shawnees attacked the house killing three people including Graham's 10-year-old son, John, and capturing 7-year-old Elizabeth. Colonel Graham was not able to secure her release until 1785. (Photograph courtesy of Susan Robinson.)

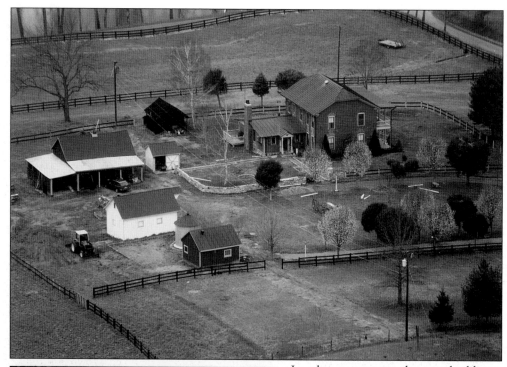

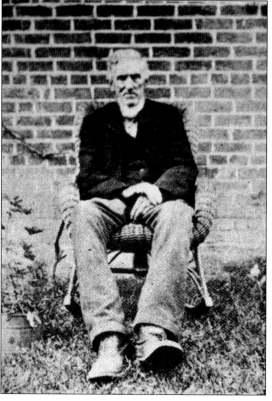

Local stonemason and master builder Silas Taylor constructed the Gwinn Plantation (pictured above) *c.* 1868 for "Long Andy" Gwinn (pictured to the left), one of the wealthiest men in Summers County. At the time, the Manor House was just one of a few brick buildings in the county. The building is an imposing large two-story dwelling with 11 rooms. Victorian porches, added in 1895, run the complete length of the front of the house on both stories. Located across the Greenbrier River from the Graham House, the Gwinn Plantation is on the National Register of Historic Places. (Photographs courtesy of Tom Bailey and the James Miller book *History of Summers County.*)

Keeney Knob rises 3,927 feet, the highest point in the county. Cincinnati balloonist Richard Clayton landed near here in April 1835. The balloon, "Star of the West," landed on the mountain, astonishing the local residents. Clayton was led to the home of Joseph Graham, an intelligent and well-educated gentleman. He stayed with Graham for three days. Many people of the area visited Clayton and marveled at his experience. Clayton, who was a watchmaker, traveled about 300 miles and stayed aloft nine-and-a-half hours. At that time, these accomplishments were United States records for hot air balloon ascents. Later in 1835, Clayton made another balloon trip in a different direction. On that trip, he carried mail. Some postal historians regard this event as the first "air mail" in the history of the United States. (Photograph courtesy of Tom Bailey.)

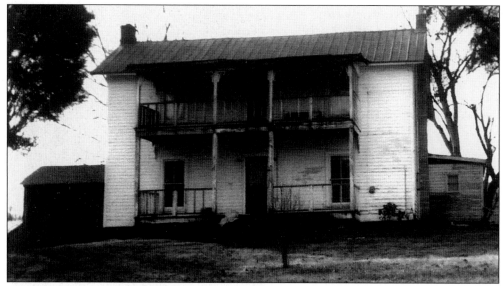

Balloonist Richard Clayton visited Joseph Graham at his home at this location in 1835. Through the efforts of local residents, a post office was established here in 1879 and named in honor of Clayton. The original house was a large two-story structure. In 1892, this present building was constructed. David Graham Ballengee, Joseph Graham's grandson, and his son Homer Ballengee served as postmasters for 60 and 19 years, respectively. The post office closed in 1959. The Ballengees were the only two postmasters at Clayton. (Photograph courtesy of Susan Robinson.)

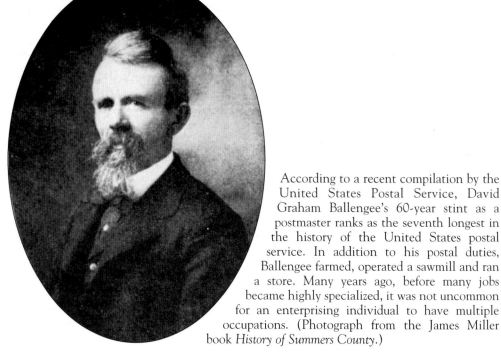

According to a recent compilation by the United States Postal Service, David Graham Ballengee's 60-year stint as a postmaster ranks as the seventh longest in the history of the United States postal service. In addition to his postal duties, Ballengee farmed, operated a sawmill and ran a store. Many years ago, before many jobs became highly specialized, it was not uncommon for an enterprising individual to have multiple occupations. (Photograph from the James Miller book *History of Summers County*.)

This statue of John Henry, the steel drivin' man, stands over the tunnel at Talcott where he defeated the steam drill in a race in the early 1870s. There are many stories and songs regarding John Henry. As a result, it is difficult sometimes to separate fact from fiction. Several historians have conducted considerable research regarding John Henry, including talking with men who worked with him. The consensus is that there was a John Henry, that he worked for the C&O, and that he defeated the steam drill. (Photograph courtesy of Newell Epperson.)

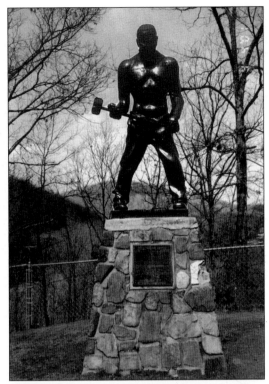

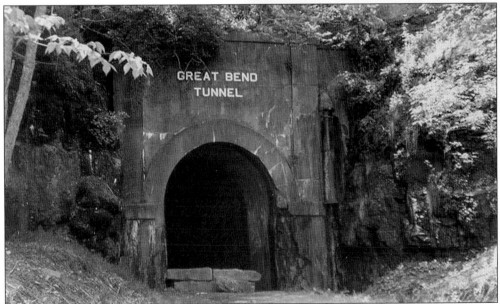

The Great Bend Tunnel at Talcott is the location where John Henry, the steel drivin' man, prevailed over the steam drill. John Henry's victory over automation saved many jobs. About 1,000 men worked on the tunnel, completed in 1873. The work was extremely dangerous with 200 men killed during the construction. Every July John henry is honored at the John Henry Days celebration in Talcott near this tunnel. The festivities include contests, music, food, and a grand parade. (Photograph courtesy of Carla Ann Leslie.)

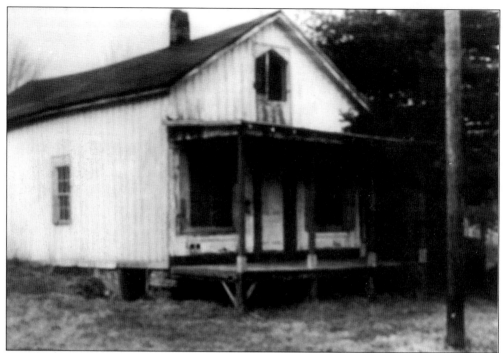

W.W. Jones, a Confederate veteran of the Civil War, built this store in Talcott in 1873. One of the earliest general stores in the county, it stayed in operation until the death of W.W. in 1915. Afterwards, the building served as Talcott's post office for 50 years. (Photograph courtesy Dillon's Superette, Talcott Memorabilia Room, Brenda Nelson collection.)

Multitalented Jim Costa has been referred to as West Virginia's Renaissance Man. A skilled curator and conservator of artifacts, he rescued the W.W. Jones store from the bulldozer. He reassembled the distinctive American Gothic building on his property several miles from its original location. It took him over three years to restore the structure, neatly painted white with green trim. Costa has collected thousands of implements used in farming, blacksmithing, and cabinetmaking. He is also a talented actor, musician, and storyteller. (Photograph by the author.)

L.G. Rhodes clerked in the W.W. Jones store in Talcott for several years. He erected this building in 1908. This photograph shows Rhodes in his automobile, the first in Talcott, in front of the store. The building presently houses Dillon's grocery store. In the back of the store, is the Talcott Memorabilia room where photographs, newspaper clippings and high school annuals are displayed. Few large towns have such a fine exhibit. (Photograph courtesy of Steve Trail.)

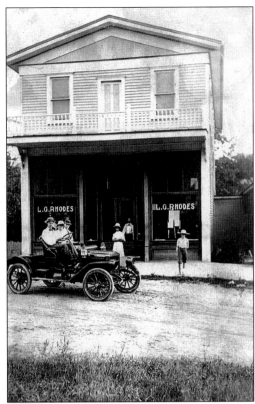

John W. (Bill) Dillon, pictured left, was Talcott's postmaster for 30 years. Summers County postmasters who have served 30 or more years include the following: David Graham Ballengee (Clayton), G.C. Landcraft (Packs Ferry), Fonda Lively (Ballengee), Harrison Gwinn (Green Sulphur Springs), John A. Richmond (New Richmond), J. Lewis Ellison (Pipestem), Edith Graham Eckle (Sandstone), Jo Ann Hoke Richmond (Meadow Creek), Charles Boyd (Green Sulphur Springs), Catherine Glass (Talcott), Mary E. Shumate (Forest Hill), Mary E. Gunter (Lockbridge), and Mrs. Bonnie Cole (Nimitz). (Photograph by the author.)

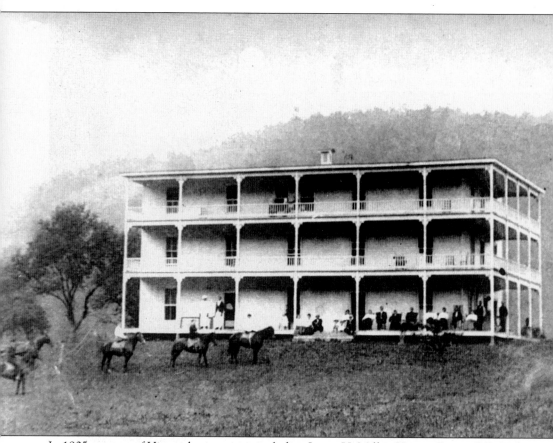

In 1905, a group of Hinton businessmen including James H. Miller, Harvey Ewart, C.B. Mahon, A.G. Flanagan, and R.R. Flanagan erected this hotel at Barger Springs. They changed the name of the community to Greenbrier Springs. For several years, the hotel was a popular place and summer resort, but by 1929 it closed. Many springs in Virginia and West Virginia were popular during the 19th century and early 20th century. Before the medical profession could cure many ailments, there was an assumption that the spring water was healthful and could cure many conditions including pneumonia, paralysis, neuralgia, gout, rheumatism, breathing disorders, and other afflictions. Visitors would drink the water and bathe in it. While it is doubtful that the water cured anyone, the belief that the water was beneficial, and a vacation in the clean mountain air probably helped to improve the physical condition of many visitors. (Photograph courtesy of Dillon's Superette, Talcott Memorabilia Room, Jim Costa collection.)

Andrew Pence, a grandson of Elizabeth Graham who survived the Shawnees attack on the Graham House in 1777, bought over 280 acres at Pence Springs in 1872. Pence started bottling water at the spring in 1882. In 1897, he built an L-shaped hotel with an observation tower. The hotel was very successful. In 1903, Pence added an annex. Fire destroyed the hotel in 1912. Workers started building the Grand Hotel in 1916 and completed it in 1918. (Photograph from the James Miller book *History of Summers County*.)

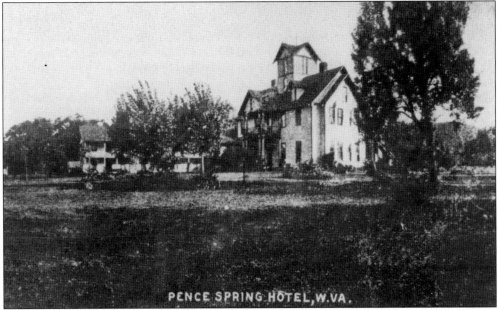

This hotel preceded the Pence Springs Grand Hotel. It had 60 rooms and could accommodate 125 guests. Workmen added the distinctive five-story observation tower in 1901. The hotel had an elegant combination ballroom and dining hall. For entertainment, the hotel featured a bowling alley, tennis courts, and a golf course. Fire destroyed this hotel in 1912. (Photograph courtesy of the Steve Trail.)

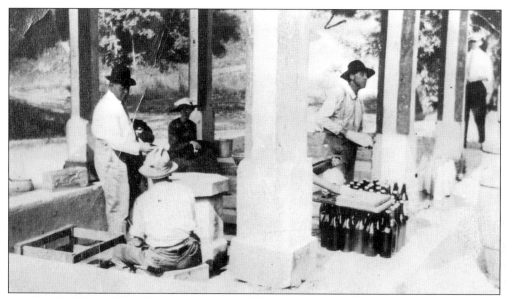

Andrew Pence started bottling water at Pence Springs in 1882. The water sold for $2 per case. Workers put the bottles of water into crates and the water was shipped across the country by railroad. This picture shows the water bottling operation. Satch Kelly is the man standing to the left. He was the official "dipper" of water for hotel guests for 30 years. Pence Springs' water won a silver medal at the 1904 St. Louis World Fair. The bottling of water ceased (c. 1935). (Courtesy of Steve Trail.)

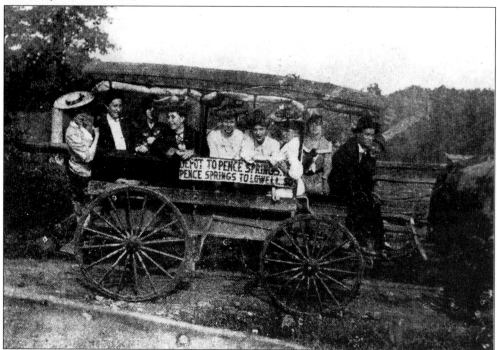

The Pence Springs "taxi" transported hotel guests between the hotel and the railroad station—about a mile. During the 1920s, trains would stop at Pence Springs as many as 14 times a day. (Courtesy of Steve Trail.)